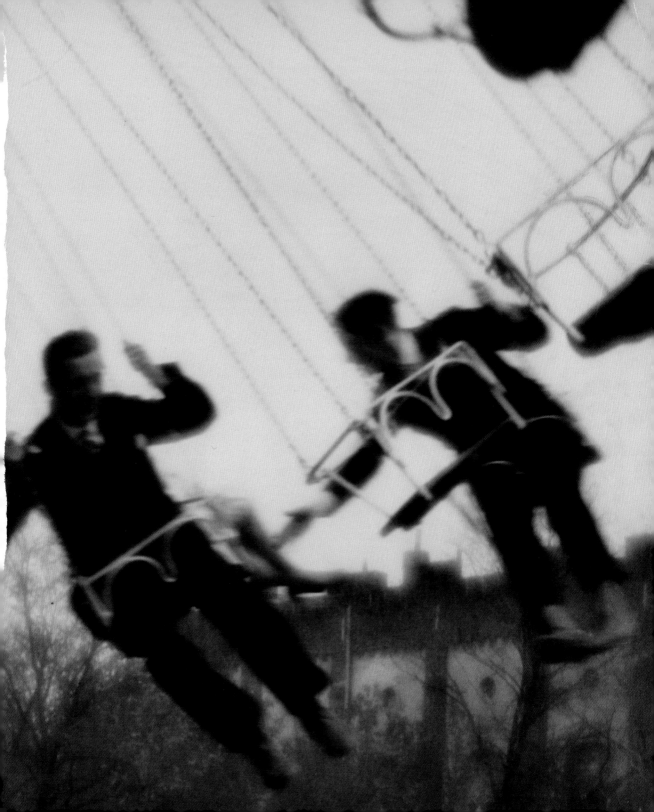

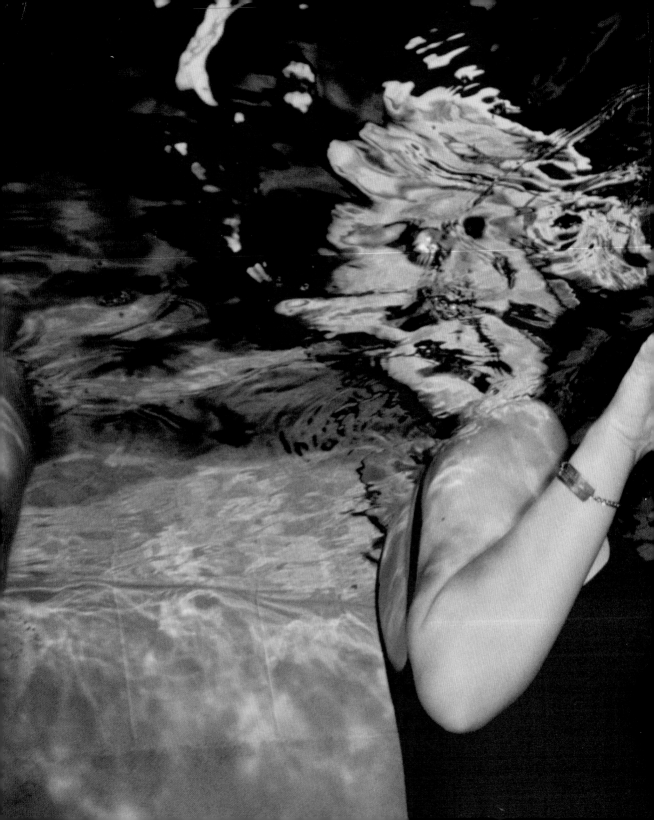

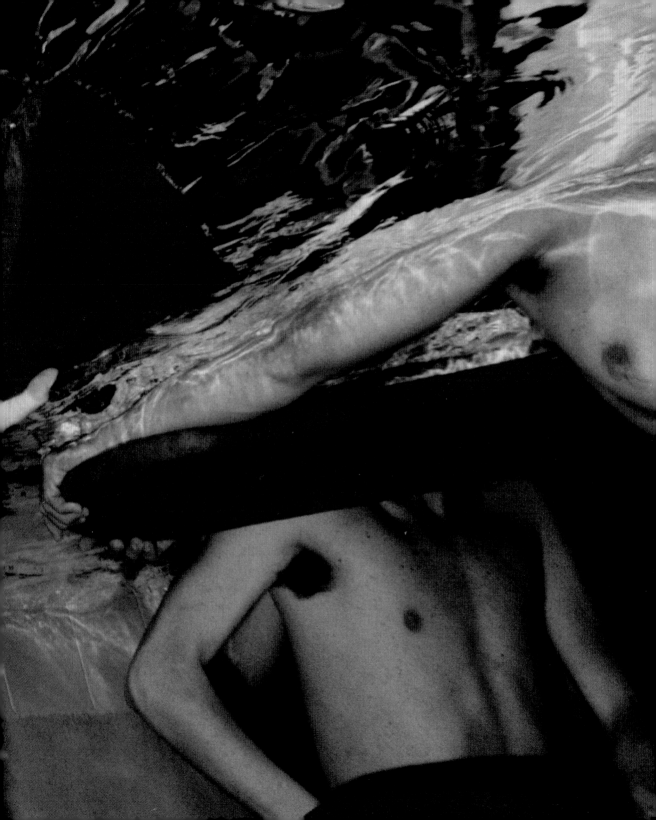

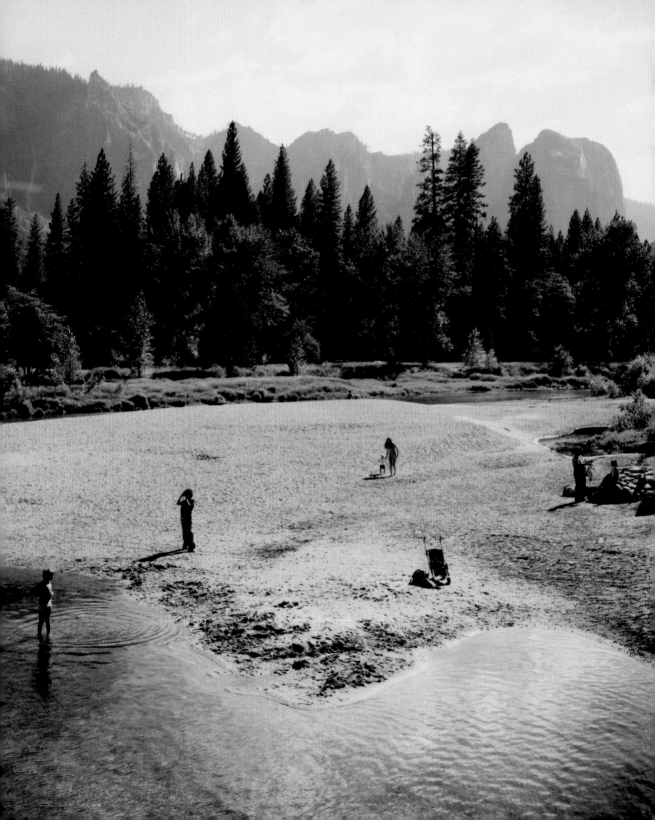

Erin C. Garcia

PHOTOGRAPHY AND Play

The J. Paul Getty Museum, Los Angeles

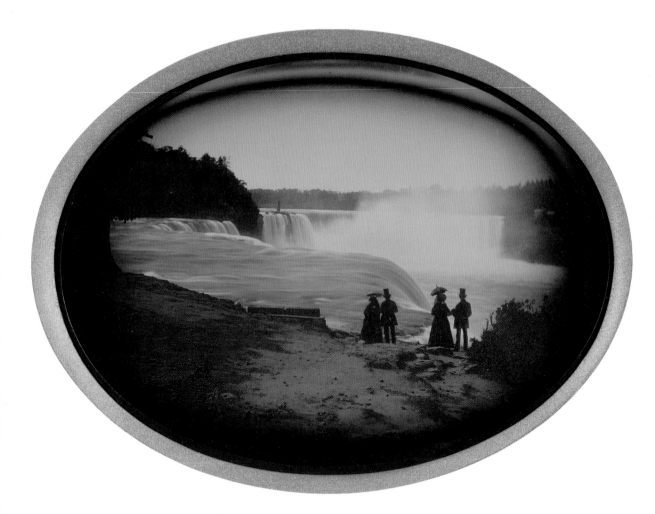

FIGURE 1. Platt D. Babbitt (American, 1823–1879), *Untitled (Scene at Niagara Falls)*, ca. 1855. Daguerreotype, 14.8 × 18.1 cm (5¹³⁄₁₆ × 7⅛ in.).
Los Angeles, J. Paul Getty Museum, 84.XT.866

Depicting Leisure

We spend the majority of our time working, studying, running households, and doing other things that we are obliged to do, yet our photograph albums tell entirely different stories. In picture after picture we are playing, celebrating, relaxing, or at least posing as if this were the case. Photography and leisure go hand in hand. Cameras are ubiquitous at places like Disneyland and Yosemite National Park. Each new destination becomes yet another photo opportunity. It is as though an experience is only made real if we take a photograph of it. With the snap of a shutter we hope to turn that one good day into something tangible, something we can hold in our hands and leave behind as a permanent record.

Leisure occupies a privileged place in our lives perhaps because we conceive of it as purely driven by pleasure and personal choice. In fact, what we do for fun is often a reflection of the goals we have for ourselves in other aspects of life. People vacation at lavish resorts to be treated like royalty. Others gather loved ones around campfires in idealized enactments of rural family life. Our choices say something about our desires. At the same time, the choices available to us are circumscribed by a complex web of factors; socioeconomics, government, race, gender, community, and religion all impinge upon what we do with our free time.[1]

Social historians disagree on when leisure, as we understand it today, became a distinct category of experience that cuts across social class. Some argue that it was not until the Industrial Revolution, with its changes in working conditions, that a new leisure class emerged in the United States and Europe. Others say that nonessential pastimes existed for many people well before the modern era. Most agree that recreational activities flourished in the nineteenth century alongside industrialization and urbanization.[2] Photography's introduction in 1839 coincided with this burgeoning culture of leisure. The new medium not only bore witness, it quickly became an indispensable component of what it meant to have fun.

The plates that follow are by no means a comprehensive look at what is a vast subject within the larger history of photography. Instead they reflect the contours of the Getty Museum's collection from which they are drawn, with its concentrations in European, American, and Japanese photography. The selections are further defined by several facts: art photography has not been representative of the experiences of all people, not all groups have had equal access to leisure, and conceptions of what constitutes

leisure have changed over time. The artists featured in this book present a diverse array of styles, techniques, and relationships to their subjects. They share an interest in the behavior and customs of the people around them. Often acting as social commentators or cultural observers, they have investigated the habits of Coney Island fun-seekers, Parisian barflies, Victorian billiard players, and suburban sunbathers. These artists, and their audiences, have found that watching people can, in itself, be entertaining and humorous.

From the nineteenth century the family vacation has been a firmly established institution among the middle class.[3] With the advent of the railroad and the steamship, Europeans not only traveled to country and seaside resorts but also toured southern Europe and the Near East. In America, majestic natural sites provided equivalents to the great monuments of Western civilization. Photographers catered to the tourist trade by selling souvenir pictures. The entrepreneurial Platt D. Babbitt, for example, had an exclusive concession from 1854 to 1870 on the American side of Niagara Falls, where he sold daguerreotype views to travelers. Babbitt's camera was set up in a small pavilion perfectly situated to capture images of visitors as they took in the spectacular falls. In a daguerreotype from around 1855 he photographed two men and two women at the spot, creating a permanent record of their fleeting encounter with the enduring grandeur of nature (fig. 1). They likely did not know they were being photographed, for it was Babbitt's practice to offer his daguerreotypes for sale only as his subjects were leaving. Visitors could not only take home the view but also proclaim: I was there.

Such declarations became commonplace and more self-conscious with the popularization of amateur photography. When handheld cameras and dry plate negatives were introduced to the marketplace in the 1880s, photography became newly accessible to ordinary people.[4] George Eastman began targeting nonprofessionals by marketing a version of the English "Detective" camera in 1888 under the name Kodak

with the now-famous slogan, "You press the button, we do the rest." In addition to making cameras, Eastman's company also processed its customers' film at its plant in Rochester, New York.[5] Without burdensome equipment or messy chemistry, amateur photographers could go out into the field, make candid portraits, and arrest moving objects. The results were often compiled into photograph albums.

One such album by an anonymous amateur typifies early collections of travel views. While most of the pages are devoted to larger photographs of cathedrals and landscapes that were purchased from professional studios, the first few pages consist of orderly rows of small, round, albumen silver prints from about 1890 (plates 46–49). The circular images, a format designed to hide lens imperfections in early Kodak cameras, document a tour of various European monuments and recreational destinations.[6] Through these portals to the past we see the Arc de Triomphe, the Eiffel Tower, a boat ride on the Seine, and cabanas at a coastal resort. Images of people engaged in various, sometimes humorous activities animate the pages. A woman rows a boat (plate 46); a man attempts to scale a wall (plate 47); a woman poses on a stile (plate 48). For the people who went on the trip, the album commemorated their adventures and saved them for posterity. Inextricably linked to moments that had already passed, the album also marks the passage of time toward the inevitable demise of its subjects. As is fundamentally the case with photography, the album constitutes an attempt to hold on to already irretrievably lost moments.

By the middle of the twentieth century, occasions for taking pictures were less momentous. Cameras were even smaller and more automated, most households in the developed world owned at least one, and widely available color film could be processed at any local drugstore. Backyard parties, days at the beach, and stops on road trips could be events that warranted a smile for the camera. Indeed, with many snapshots it seems that taking a picture was an end in itself. See, for example, *People at Leisure* (fig. 2), an assemblage

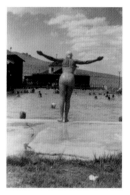

FIGURE 2. Gail Pine (American, b. 1951) and Jacqueline Woods (American, b. 1965), *People at Leisure*, 2006. Nine gelatin silver prints, each ranging from 7.8 × 5.2 cm (3⅛ × 2¹/₁₆ in.) to 7.9 × 11.9 cm (3⅛ × 4¹¹/₁₆ in.), mounted on paperboard. © Pine and Woods, 2006. Gift of Michael and Sharon Blasgen and Wilson Centre for Photography. Los Angeles, J. Paul Getty Museum, 2007.51.10.1–.9

of nine found photographs dating from the 1930s to 1968 and configured into a grid by Gail Pine and Jacqueline Woods in 2006. In one of the images a woman in a swimsuit and bathing cap perches at the edge of a pool with her arms outstretched, pausing momentarily for the camera before diving in. In another a woman sitting on the beach looks into the camera as if to say: Here I am, right next to the Good Humor sign.

The pervasiveness of amateur photography at tourist and vacation destinations began to attract the attention of artists. In a 1980 photograph from his Sightseer series (plate 2), Roger Minick comments on the phenomenon of taking in the sights through visual juxtaposition. A tourist, seen from behind, obstructs the famous view of Yosemite Valley from Inspiration Point, a spot that is practically synonymous with photography. The woman wears a souvenir headscarf illustrated with views of the valley, pointing to the transformation of nature into entertainment and commerce. In a 1981 work from his series Counting Grains of Sand (plate 82), Hiromi Tsuchida turns his camera against a sea of Japanese photographers wearing nearly identical sunhats and looking into the viewfinders of their 35 mm cameras. Tsuchida deprives us of the view they obviously find noteworthy; we see only the crowd of men determined to acquire it.

As photography exploded among amateurs from the nineteenth to the twentieth century, so too did interest among artists in documenting how people live. If nature and travel gave tourists an occasion to pick up their cameras, it was the modern urban environment that inspired artists to do the same. The city has been the subject of modern art from the very beginning. Paris's cafés, cabarets, and circuses captivated the Impressionists and many painters who came after them. Photographers also took to the streets to record the spectacles of everyday life. The camera seemed ideally suited to capture the spontaneity of the urban milieu. Walking through neighborhoods, waiting for something to photograph, and then seizing on a particular moment became the common mode of operating for street photographers and photojournalists.

Eugène Atget, working at the end of the nineteenth century, was an influential forebear of twentieth-century street photography. His subject was old Paris, and he made an extensive record of the city's architectural details, cobblestone alleys, and shop windows. As he intended these views to serve as documents for artists and draftsmen, he generally excluded details of modern life. Nevertheless, Atget did occasionally make candid pictures of people. In the Luxembourg Gardens he photographed children playing with pails and hoops (plate 36) and a young audience enjoying a puppet show (plate 13). It is hard to imagine that Atget, with his large camera and tripod, escaped the notice of his subjects, yet these charming photographs are clearly scenes of unrehearsed leisure.

To catch people truly unaware, photographers had to be more mobile. The increasingly smaller cameras and quicker films available as the twentieth century progressed enabled artists to move among crowds, photograph people without their knowledge, and depict objects in motion. Edward Steichen, not generally known for reportage, took a small camera to the Longchamp racetrack on Steeplechase Day in 1907, where he snapped a picture of elegantly dressed society women about to board a carriage (plate 22). Their ensembles appear all the more confectionary in contrast to the modest clothing of a poor flower seller to the left.[7] Moving shoulder to shoulder with the crowd and focusing on the spectators rather than the action on the field, Steichen conveyed an important aspect of going to the races: seeing and being seen. The act of viewing, as with sightseeing, is deeply intertwined with the experience of urban leisure. Walker Evans explored this notion in pictures he made on the promenade at Coney Island in the 1920s. Evans went unnoticed as he surreptitiously photographed fashionable boardwalk strollers from behind. In one photograph a woman in a floral dress surveys sunbathers on the sand below, apparently unaware that she is herself being observed (plate 3).

The cacophony of sights and sounds in the modern urban environment seemed to demand dynamic pictorial responses. Carnivals and amusement parks of the 1920s gave photographers opportunities to express sensory experiences visually. Martin Munkacsi's blurry photograph *Kettenkarussel (Swing Carousel)* (plate 10) captures the exhilarating centrifugal force of a ride that spins two men at a steep angle to the ground. Amusement parks also allowed photographers to document behavior not typically seen elsewhere. Brassaï (Gyula Halász) photographed a couple on a swing at a Paris carnival (plate 11), capturing the moment when, at the basket's peak, the man lurches against gravity for a kiss.[8] Atget's *Fête du Trône (Street Fair)* (plate 12) makes an irresistible comparison. Perhaps taken before the fair opened, *Fête du Trône* is eerily deserted of people, as though Atget's camera and the carousel are standing still in time while the rest of the world moves on. In stark contrast, Brassaï and Munkacsi embrace the buzz and whir of the modern city with its promises of yet-to-be-discovered pleasures.

The illustrated press, which had grown in popularity in the United States and Europe since the 1920s, fed the desire for pictures of everyday life. Stories about recreation and entertainment made popular features. Captioned photographs lent immediacy to the printed page and allowed readers to participate vicariously in the lifestyles of others. Photojournalists often worked independently, searching for high-impact images that could tell stories. Weegee (Arthur Fellig), a well-known tabloid photographer, kept his camera focused on New York City's neighborhoods. He recorded the ecstatic faces of boys and girls cooling off in the water from an open fire hydrant as they briefly co-opted a street on the Lower East Side for their own delight (plate 38). The photograph presents a romantic image of Depression-era New York as a place of both innocence and irreverence. In about 1935 Magnum photographer Henri Cartier-Bresson happened upon a similarly impromptu scene of child's play in the blown-out shell of a building in Seville, Spain (plate 37). Like the children, Cartier-Bresson improvised

with the unintended props and unexpected visual juxtapositions of the urban landscape, framing the makeshift playground with a large hole in a nearby wall. He was less interested in reporting notable events than in communicating an experience of the world artistically.[9]

City streets and public gathering spaces have long been described as stages on which social life is played out. By night, however, the cover of darkness brings expectations of privacy. For photographers, nightfall presents the opportunity to observe furtive behavior. Having moved to Paris from his native Hungary, Brassaï was eager to explore the social mores of his new home. His nocturnal wanderings took him to the city's secret underworld of bars, opium dens, and lonely street corners. In *Two Butchers Dancing, Paris* (plate 30) of about 1931, he captured the tentative embrace of male partners surrounded by other same-sex couples on a dance floor. Influenced by Brassaï, Bill Brandt made similar forays into London's nightlife after moving to England from Germany. His photograph *In a London Bar (At Charlie Brown's, Limehouse)* (plate 26) of 1945 shows a couple kissing despite the presence of a man sharing their table. Both Brandt and Brassaï worked as though undercover, slyly pretending to fit in as they investigated the dark passions of their adopted homes. Published in books and magazines, their photographs made viewers complicit in these clandestine acts of voyeurism.

Public space puts people on display for observation. Photography, and by extension the popular press, expanded the viewing arena and allowed people to peer into the lives of others from the privacy of their own homes. It could also make private space visible to a public audience. Early examples of candid domestic scenes are unusual. Though Victorian homes offered numerous amusements, limited light made them problematic settings for photography in its early days. Roger Fenton's *The Billiard Room, Mentmore House* (plate 52), in which men and women play a game of billiards, provides a rare glimpse into a nineteenth-century English drawing room. Gertrude Käsebier used the technical

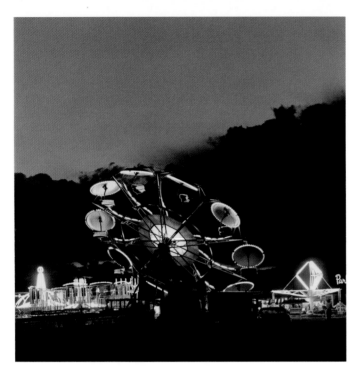

cations such as *Sunset* magazine promoted indoor/outdoor living, a new model of domesticity that incorporated recreation into the home where it was safe from the uncertainties of the world outside.[10]

While recognizing the allure of suburbia a number of artists also cast a critical eye on it. Robert Adams's photographs of housing developments in Longmont, Colorado, underscore the encroachment of human activity into the landscape. In one 1976 work from the series, a brightly lit Ferris wheel set against the mountains at night looks like a spaceship landing in the desert (fig. 3). In *Backyard, Diamond Bar, California* (plate 59), Joe Deal reveals the expansive space intended for recreation behind a two-story tract home. The horizon is cluttered with nearly identical houses surrounded by cinder-block walls that define the protective confines of private space. A swing set and patio furniture sit at the edge of a teardrop-shaped swath of turf that suggests a not-yet-built swimming pool. Devoid of people, with only the trappings of leisure, the photograph hints at alienation and loneliness.

With cool neutrality both Adams and Deal stood at distance from their subjects. Bill Owens took a close-up look at suburbia when he documented everyday moments in the lives of people in his own community. In the 1960s he and his young family settled in suburban Livermore, California, where he worked as a photojournalist for the town's daily newspaper. Behind the veil of garage doors and backyard fences, Owens found people showing off their hobbies (plates 57, 62), cooking at barbeques (plate 60), and throwing Tupperware parties. The conversational captions that accompany his photographs point to the easy interactions he had with his subjects: "Sunday afternoon we get it together. I cook the steaks and my wife makes the salad." The transparency of Owens's approach seems only to exaggerate the comical ordinariness of the people he photographed.

Owens's subjects were sometimes more than willing to expose the details of their private lives to him. *Untitled (Swimming Pool)* (plate 63) perfectly encapsulates the reputedly free-and-easy lifestyle

limitations of indoor photography to her artistic advantage in a portrait of herself at a billiard table (plate 53). Light from a doorway spills into the room diagonally in line with her outstretched arm and pool cue.

While flash photography soon solved the problem of taking pictures indoors, domestic recreation moved outside in the twentieth century. The home took on new significance as a site for leisure in postwar American suburbs. Following the Great Depression and World War II, developers met the surging demand for housing by creating whole towns from scratch on large tracts of raw land. People fled the crowded, crime-ridden tenements and apartment blocks of big cities for detached homes with their own garages, front lawns, and backyards. In the Sun Belt, modern "ranch houses" often came with that ultimate trophy of middle-class achievement—a swimming pool. Publi-

FIGURE 3. Robert Adams (American, b. 1937), *Summer Night, Longmont*, negative, 1976; print, 1982. Gelatin silver print, 12.7 × 12.7 cm (5 × 5 in.). © Robert Adams. Los Angeles, J. Paul Getty Museum, 2003.117.14

of California in the 1970s. Two bikini-clad women straddle the shoulders of men in a pool in a playful battle to knock each other into the water. The social upheavals of the previous decade had profoundly altered mainstream values. One result of shifting social norms was more casual attitudes toward sexuality. With tangled body parts, wet hair, and drunken smiles, the adults in Owens's photograph flaunt their new freedoms for his camera. Play is, after all, an opportunity to pretend to do things that, for fear of consequences, would otherwise be off-limits.

Few places outside the home permit people to be fully at ease. At the beach, the bounds of propriety give way to the desire for respite. It has its own set of rules that changes with cultural values. Increasingly relaxed standards for public undress are just one example. Lisette Model's curiosity about a bather she observed in the 1930s on the Promenade des Anglais toys with unspoken admonitions against too-careful inspection of other bodies (plate 77). She photographed the woman, apparently without her knowledge, from a surprisingly intimate vantage point

that accentuates her large thighs. In his 1949 photograph *High School Beach, Los Angeles* (plate 81), Max Yavno's wide view reveals the beach to be a condensed version of the city, where sunbathers stake out real estate and socialize from one encampment to another. Garry Winogrand treated the beach in much the same way as he photographed New York City, by cultivating the visual style of snapshot photographs. In a work of the 1970s from his series Women Are Beautiful (fig. 4), the tilted horizon line, off-center composition, and intrusion of the photographer's shadow intentionally mimic the work of an untrained amateur. Lauren Greenfield's *Mijanou and Friends from Beverly Hills High School on Senior Beach Day, Will Rogers State Beach* (plate 80) presents the beach as an extension of high school, where mating rituals and the social pecking order play out. Affluent teenagers in expensive cars interact with one another in ways that perhaps are not tolerated quite as openly at school.

Artists interested in examining contemporary life have sought out similarly gray areas within the public

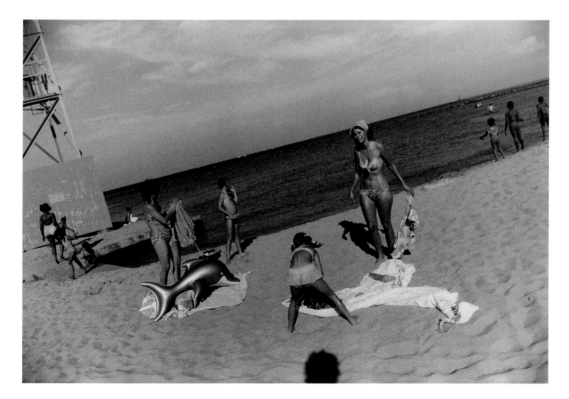

FIGURE 4. Garry Winogrand (American, 1928–1984), *Untitled (Beach Scene)*, ca. 1970s. Gelatin silver print, 22.1 × 33 cm (8¹¹⁄₁₆ × 13 in.). © 1984 The Estate of Garry Winogrand. Los Angeles, J. Paul Getty Museum, 2004.50.11

sphere. For his Picnic series of 2005, Masato Seto photographed couples relaxing in Japanese parks. In one image a woman lies on top of a man in tall grass, out of view from a nearby city (plate 75). In another scene a young man reclines on a hard stone walkway next to a woman smoking a cigarette (plate 74). The couples act as though they are alone but also acknowledge the camera. The series refers back to *Le Déjeuner sur l'herbe (The Luncheon on the Grass)* of 1862–63, the famous Impressionist painting by French artist Édouard Manet in which a naked woman looks directly at viewers while her fully clothed male companions converse. Seto's photographs share a similar ambiguity, one created by the guarded frankness of his subjects and the unself-consciousness with which they comport themselves. They are not trespassing or loitering, yet they seem to press the limits of decorum.

Seto's photographs speak to the simple pleasure of being outdoors even when that space is compromised. In his series Where We Find Ourselves, Justin Kimball also examined recreation in less-than-idyllic settings. In *East Greenwich, Rhode Island* (plate 70), a girl perches uncomfortably on a rock near a boy who wears pants unsuitable for bathing at a graffiti-adorned swimming hole. In *Orange, Massachusetts* (plate 71), a group of boys prepares to jump into a river from a roadside guardrail. Kimball's photographs depict far-from-picturesque Arcadias, such as the one conjured in Thomas Eakins's 1884 *Male Figures at the Site of "Swimming"* (plate 68), a staged study for a painting. Paradisaical visions go unfulfilled for Kimball's vacationers, but they make do. There is an open-ended quality to these images that suggests contemporary uncertainty about our relationship to the environment.

Nature and its inhabitants appear a little tired and unhealthy, yet there is still promise here of rejuvenation, new adventures, and summer flings.

In the nearly two centuries since its inception, photography has had countless applications. Perhaps one of the most gratifying uses has been in its ability to reflect back images of ourselves. How precious to hold in our hands the memory of standing at the edge of Niagara Falls or to turn the pages of an album filled with summertime adventures. There is also the vicarious pleasure of watching other people have fun. We can instantly relate to the thrill of two men on a carnival ride or the delight experienced by children playing in the spray of water from an open fire hydrant. Often our gaze is more prurient: we cannot help being interested in what goes on in Parisian nightclubs and backyard hot-tub parties. In other instances, we find it satisfying to be on the knowing side of a photographer's critical lens as it scrutinizes the trappings of the "good life" or pokes fun at eccentrically dull suburbanites.

Some photographers remind us that we are never more likely to use our cameras or to be photographed than when we are vacationing. Taken literally, vacation means "to vacate" one's normal, workaday life for a period of time. Likewise, photography allows us to steal moments away from their place in time and carry them into the future. Looking at pictures, we briefly abandon our daily routines and escape into our memories or into the lives of others. Photography is unique in its capacity to visually transport us from one reality to another, and that has made it our ideal companion in leisure.

NOTES

1 This is the general premise of Peter Borsay's *A History of Leisure: The British Experience since 1500* (Basingstoke, England, 2006).

2 Borsay, *A History of Leisure* (note 1), p. 15.

3 Dona Brown, *Inventing New England: Regional Tourism in the Nineteenth Century* (Washington, D.C., 1995), p. 7.

4 See Brian Coe and Paul Gates, *The Snapshot Photograph: The Rise of Popular Photography, 1888–1939* (London, 1977), pp. 16–17.

5 William Welling, *Photography in America: The Formative Years, 1839–1900* (Albuquerque, New Mexico, 1987), p. 285. See also Douglas Collins, *The Story of Kodak* (New York, 1990), pp. 53–55.

6 Collins, *The Story of Kodak* (note 5), p. 56.

7 Penelope Niven, *Steichen: A Biography* (New York, 1997), p. 241.

8 Diane Elisabeth Poirier, *Brassaï: An Illustrated Biography,* trans. Jennifer Kaku (Paris, 2005), p. 34.

9 Brett Abbott, *Engaged Observers: Documentary Photography since the Sixties* (Los Angeles, 2010), pp. 15–16.

10 Alan Hess, introduction to *The Ranch House* (New York, 2004), pp. 14–15.

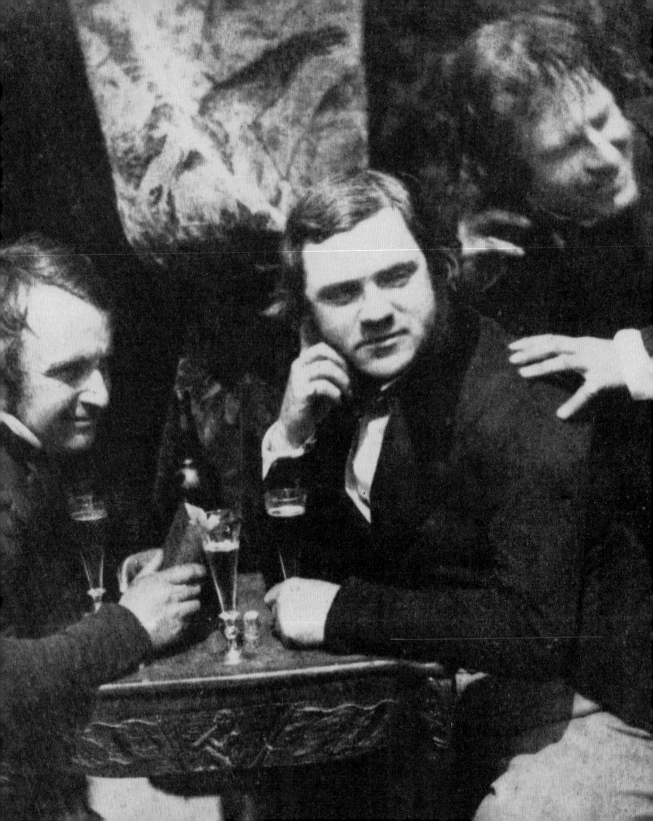

PLATES

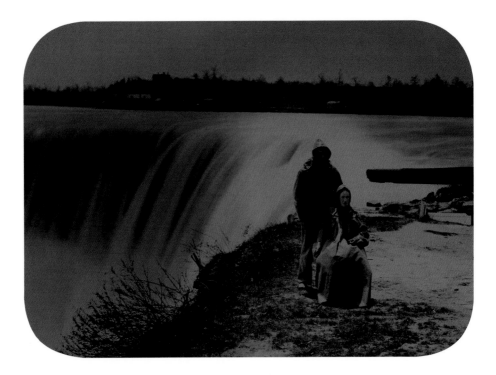

1 ATTRIBUTED TO HENRY HOLLISTER
Untitled (Couple at Niagara Falls in Waterproof Clothing), 1860s

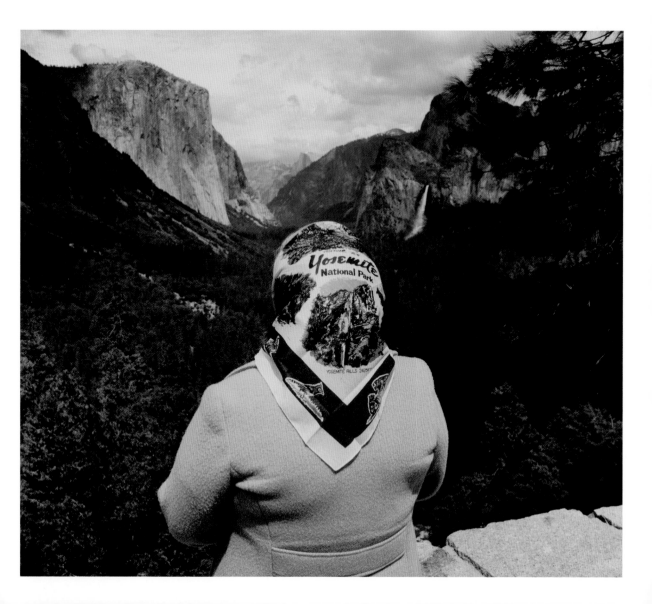

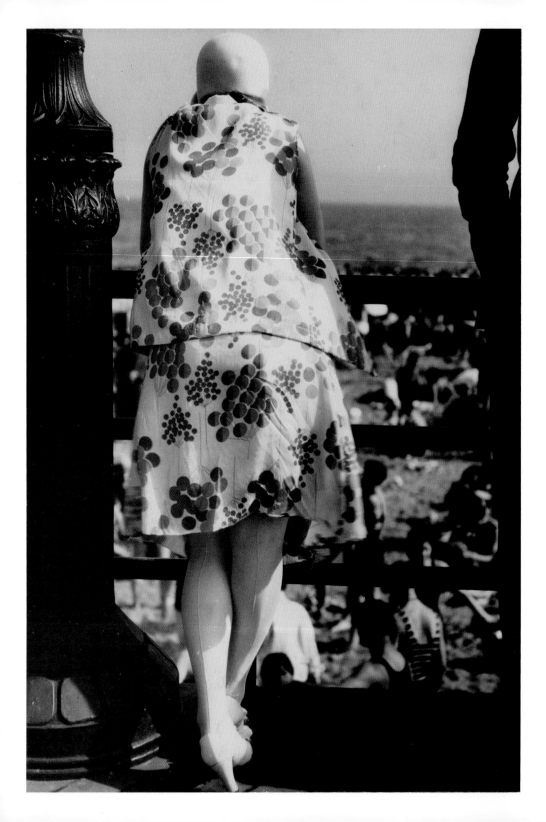

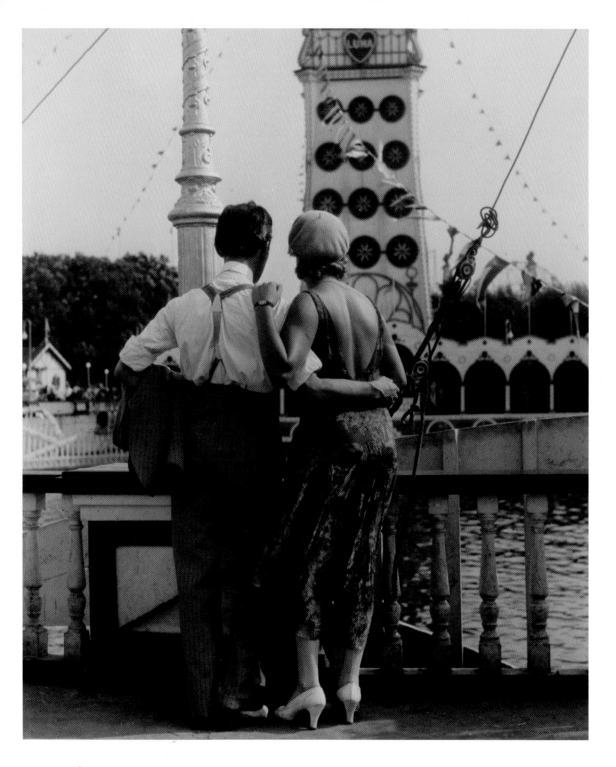

3 **WALKER EVANS**
Coney Island Boardwalk, 1929

4 **WALKER EVANS**
Couple at Coney Island, 1928

5 **LOUIS FLECKENSTEIN**
Untitled (Carousel), ca. 1910

6 **HANS VOLLHARDT**
Untitled (Mirror Distortion with Students and Camera), ca. 1929

7 **HANS VOLLHARDT**
Untitled (Mirror Distortion with Four Students and Camera), ca. 1929

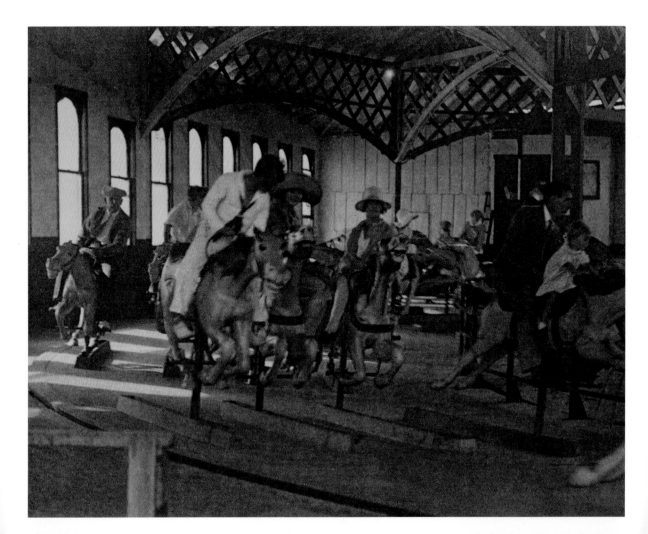

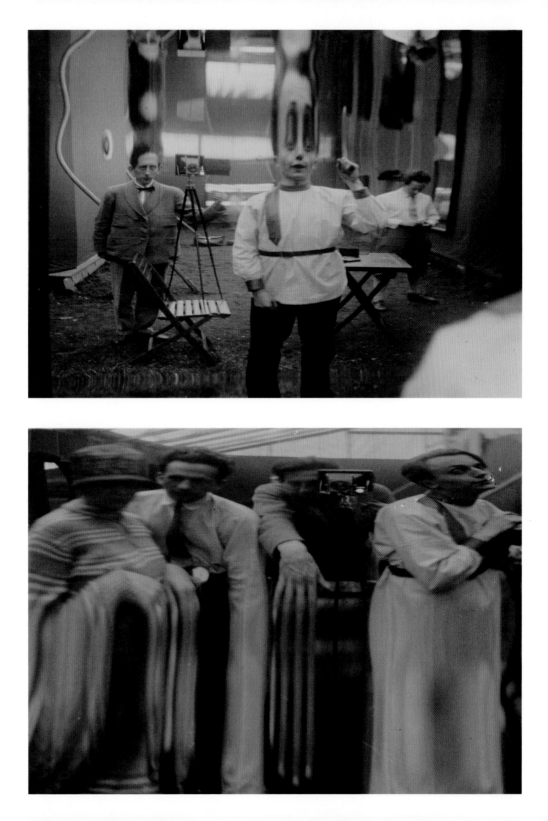

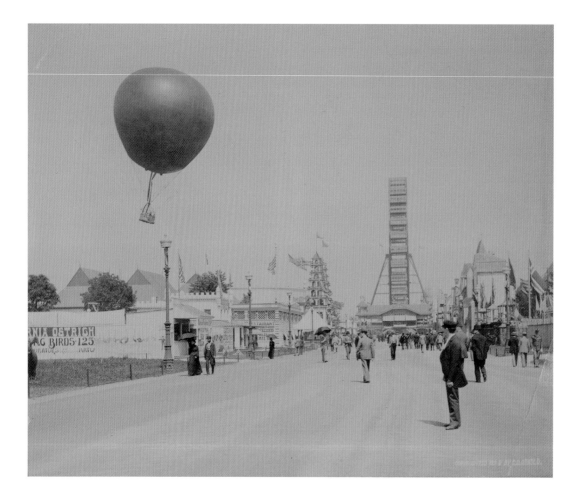

8 **CHARLES DUDLEY ARNOLD**
Captive Balloon and Ferris Wheel, World Columbian Exposition,
Chicago, 1892–93

9 **BRASSAÏ**
Balloon Seller, Montsouris Park, Paris, negative, 1931;
print, 1934

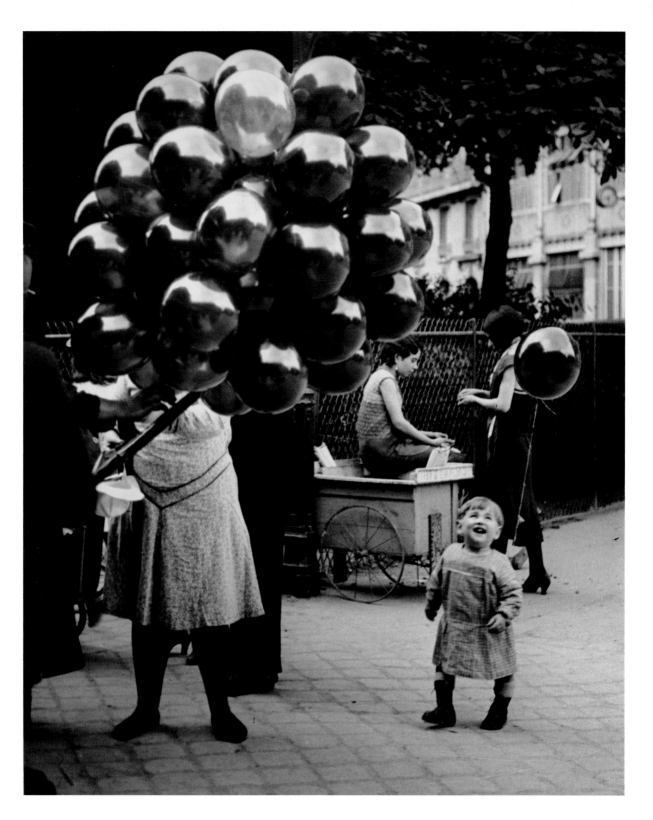

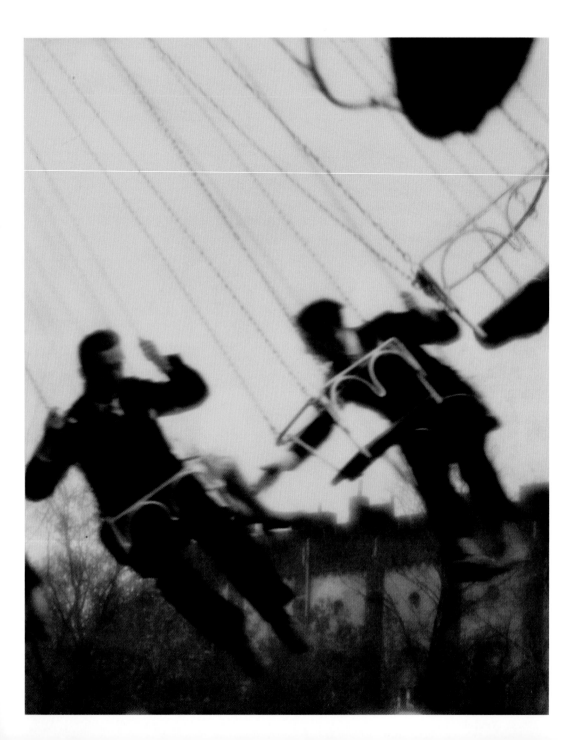

11 BRASSAÏ
Kiss on the Swing, Paris, 1935–37

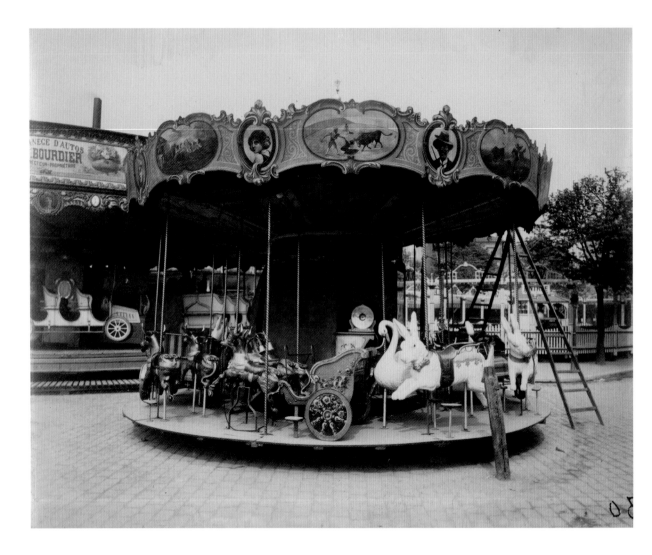

12 **EUGÈNE ATGET**
Fête du Trône (Street Fair), 1923

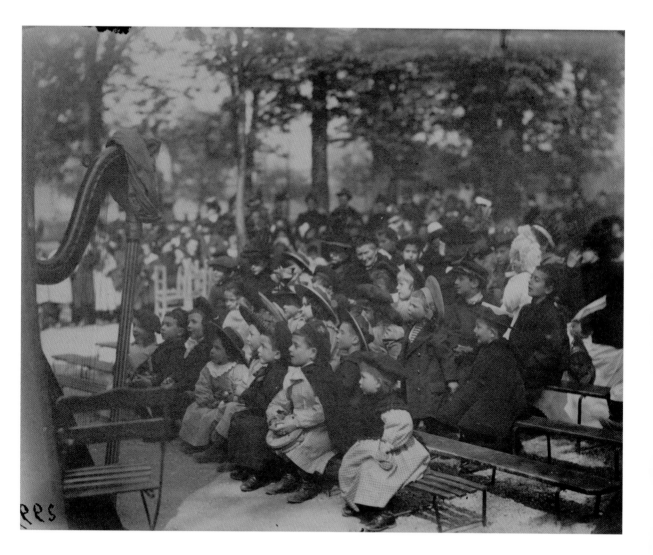

13 **EUGÈNE ATGET**
Guignol, Jardin du Luxembourg (Puppet Show, Luxembourg
Gardens), 1898

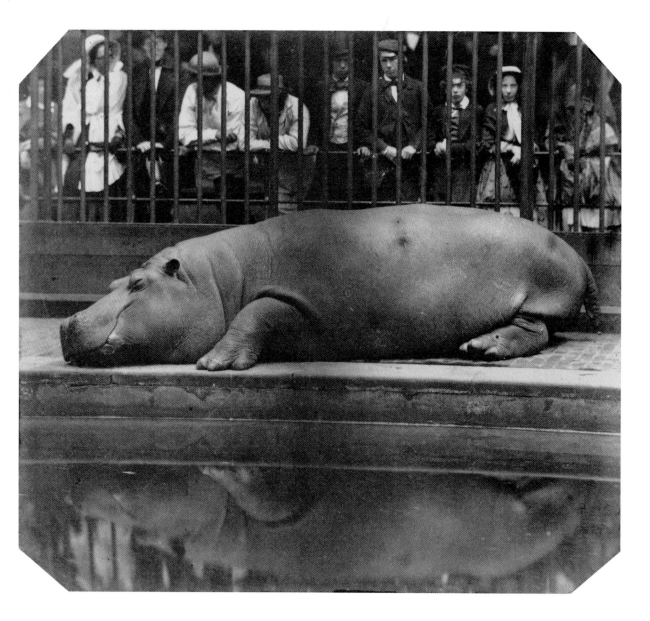

14 COUNT DE MONTIZON

The Hippopotamus at the Zoological Gardens, Regent's Park, 1852

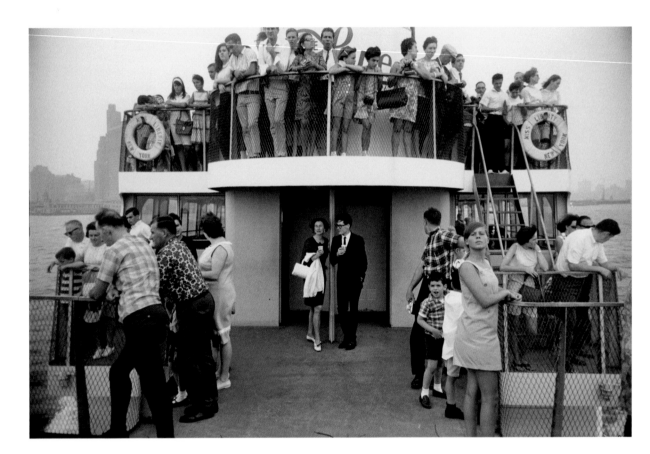

15 **GARRY WINOGRAND**
Miss Liberty, Circle Line, Hudson River, New York, 1971

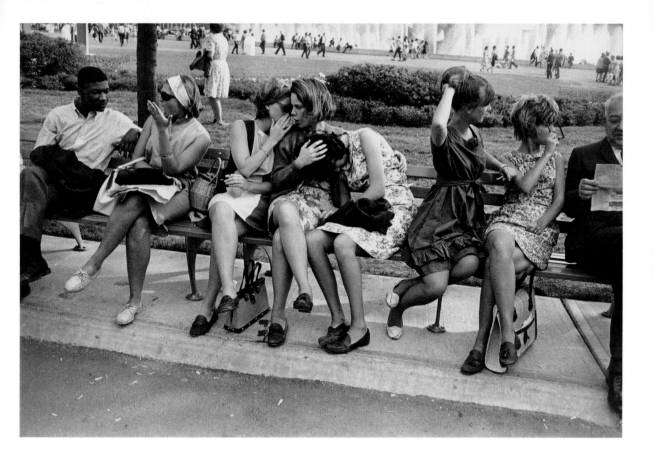

16 **GARRY WINOGRAND**
World's Fair, New York City, 1964

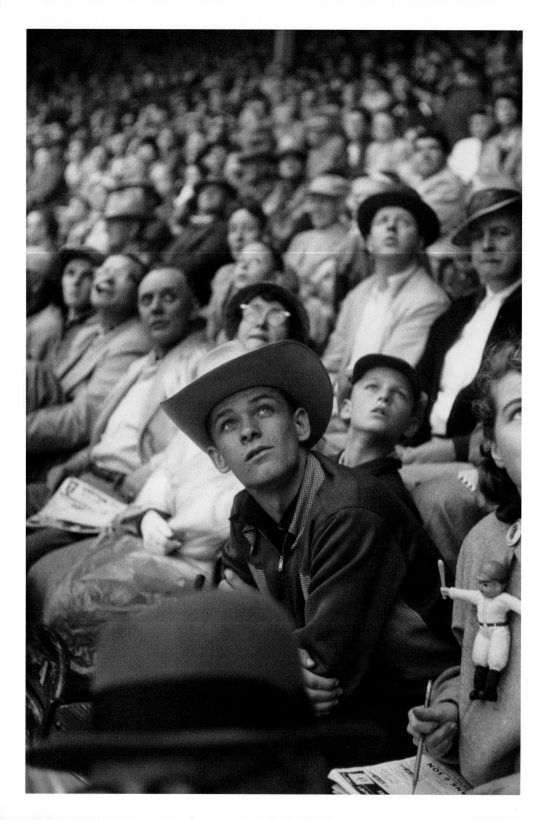

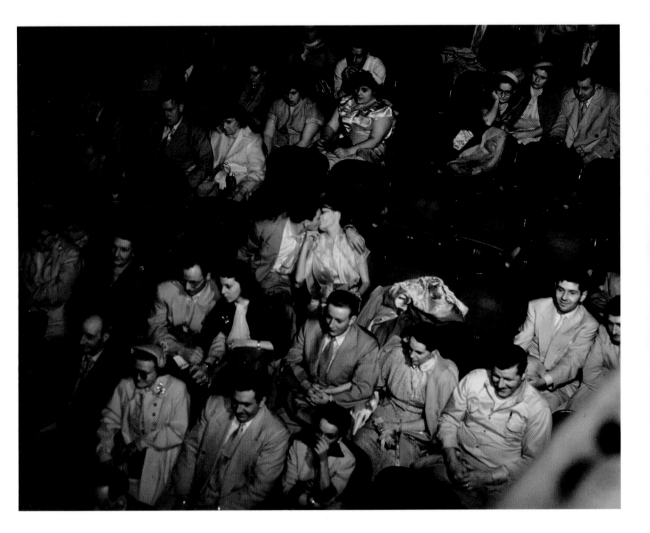

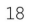 17 **HENRI CARTIER-BRESSON**
The Baseball Fever, 1957

18 **WEEGEE**
Audience in the Palace Theatre, ca. 1953

19 **HENRI CARTIER-BRESSON**
Horse Racing at Miami's Hialeah Race Track, 1957

20 **LISETTE MODEL**
Belmont Park Race Track, Couple with Cigarettes, 1956

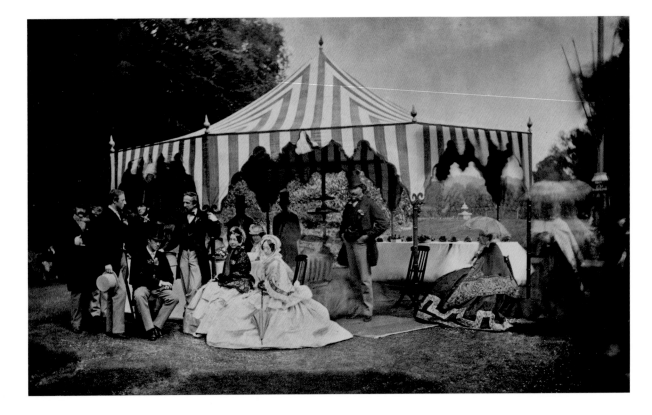

21　CAMILLE SILVY
Untitled, 1864

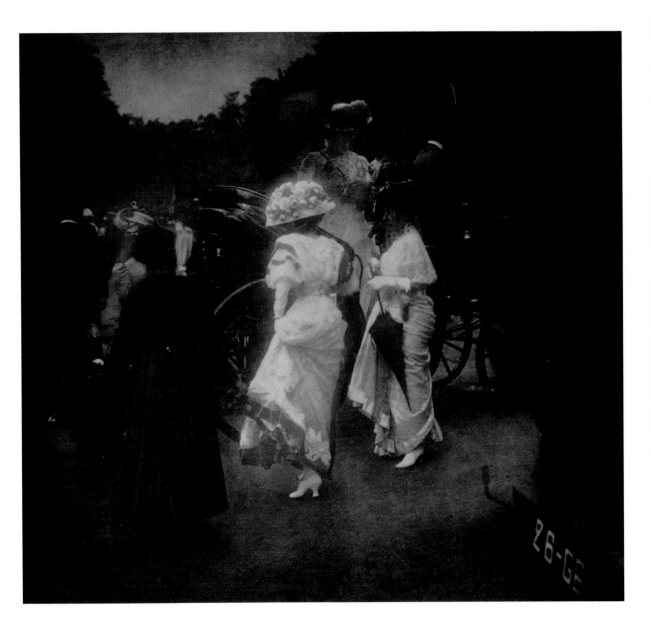

22 EDWARD STEICHEN
Grand Prix at Longchamp, After the Races, 1907

23 **GARRY WINOGRAND**
Centennial Ball, Metropolitan Museum, New York, 1969

24　WEEGEE
The Body Beautiful / Celebrating, November 1943

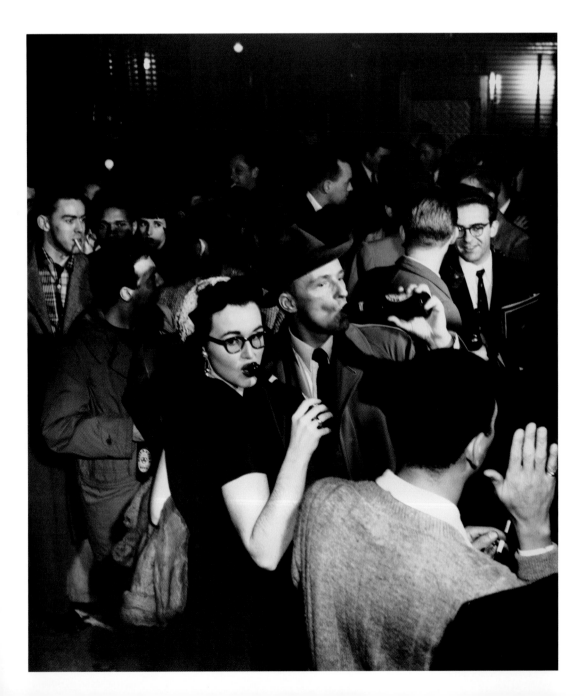

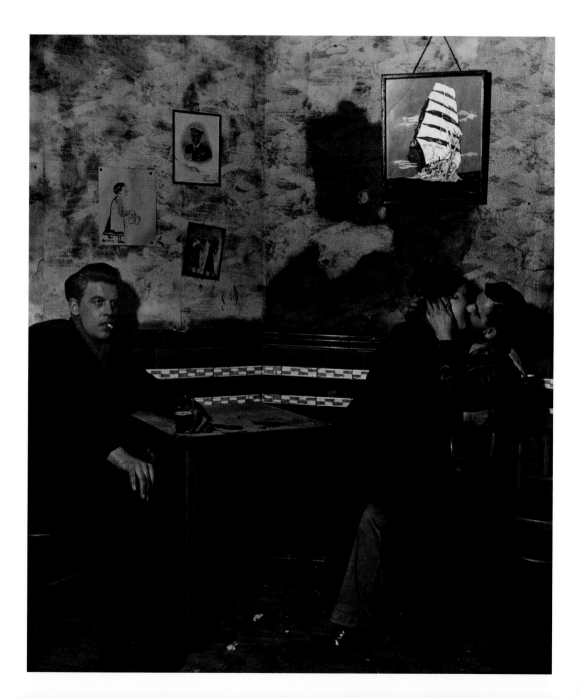

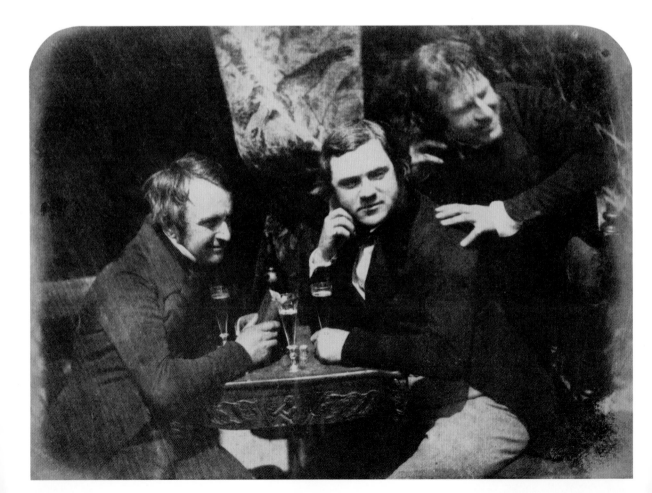

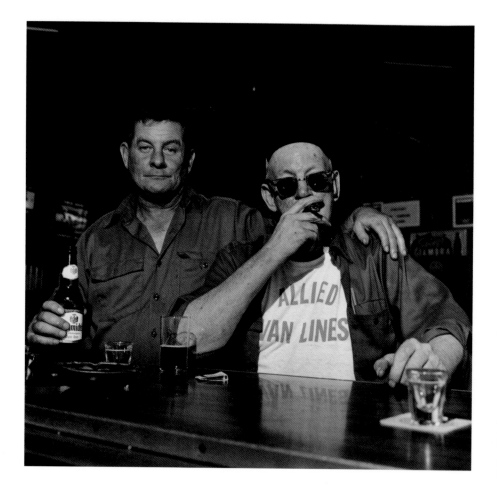

28 **MILTON ROGOVIN**
Lower West Side, 1973

29 **PAUL WOLFF**
Couple Dancing, 1940s

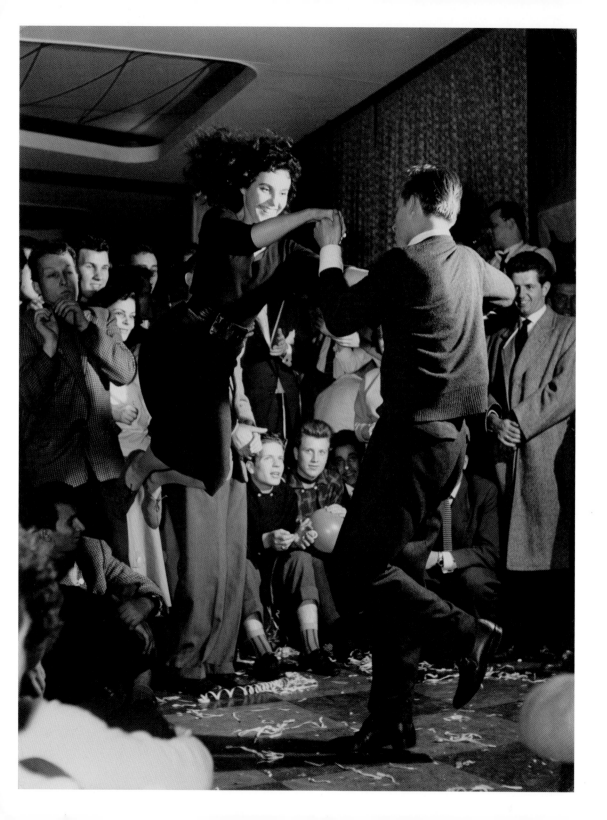

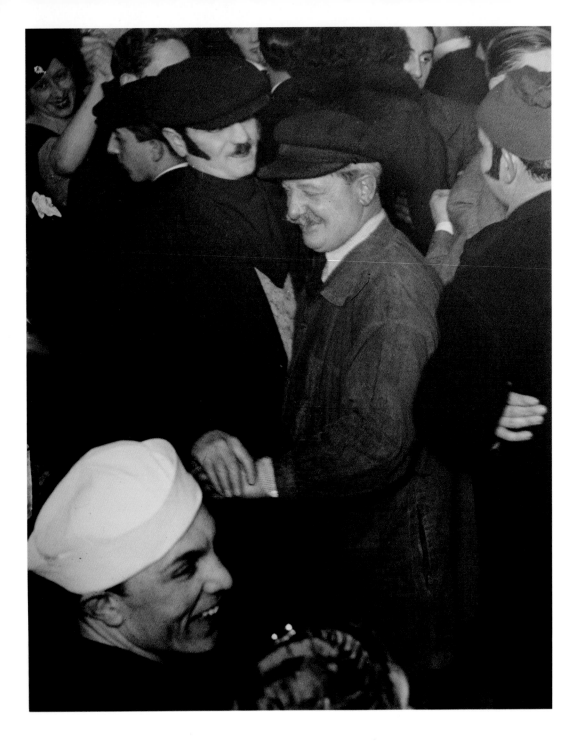

30 **BRASSAÏ**
Two Butchers Dancing, Paris, ca. 1931

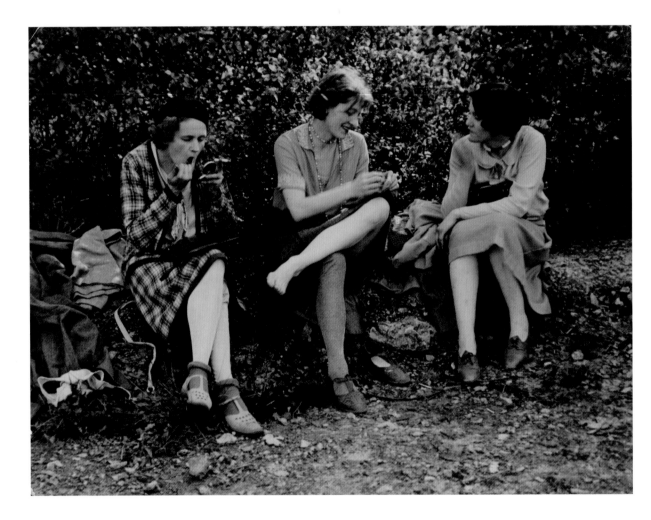

32　ANDRÉ KERTÉSZ
Untitled (Sari Dienes and Friends), 1930

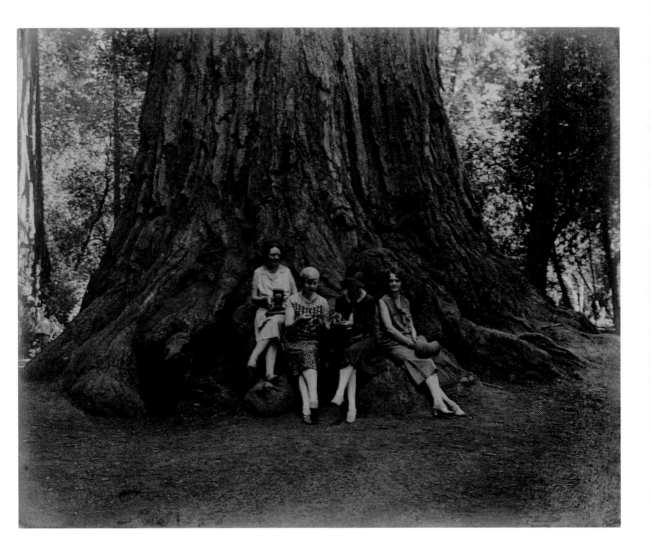

LOUIS FLECKENSTEIN
Untitled (Women with Cameras at the Base of a Tree), ca. 1900

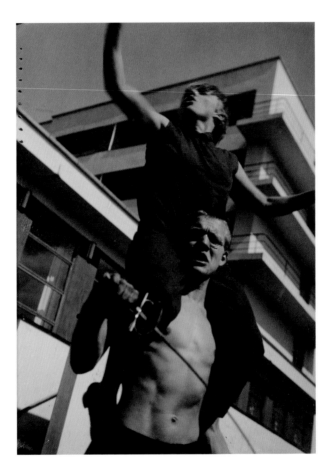

34 **T. LUX FEININGER**
Untitled (Georg Hartmann with Karla Grosch on His Shoulders
outside the Bauhaus), 1929

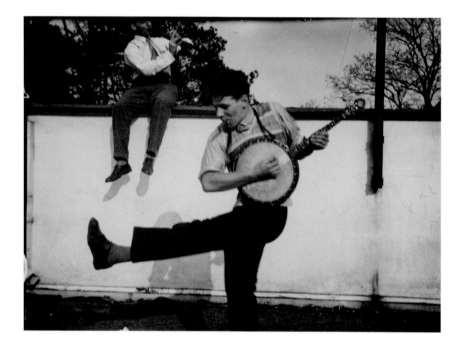

35 **T. LUX FEININGER**
Untitled (Two Members of the Bauhaus Band Playing the Banjo
and Clarinet), ca. 1928

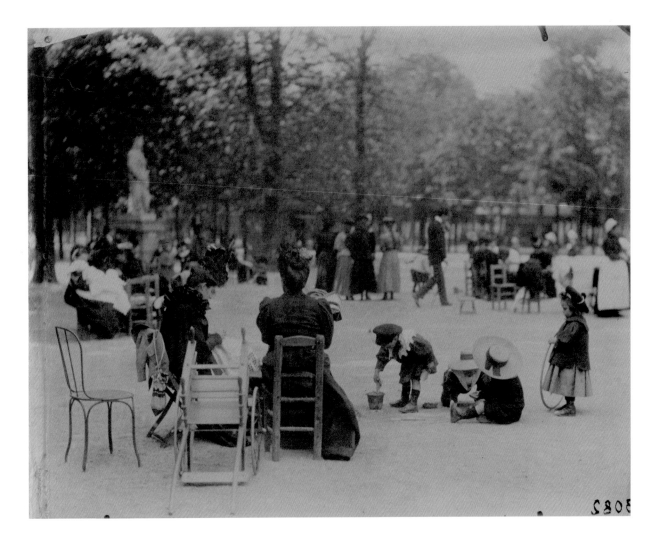

EUGÈNE ATGET
Women and Children in the Luxembourg Gardens, 1898

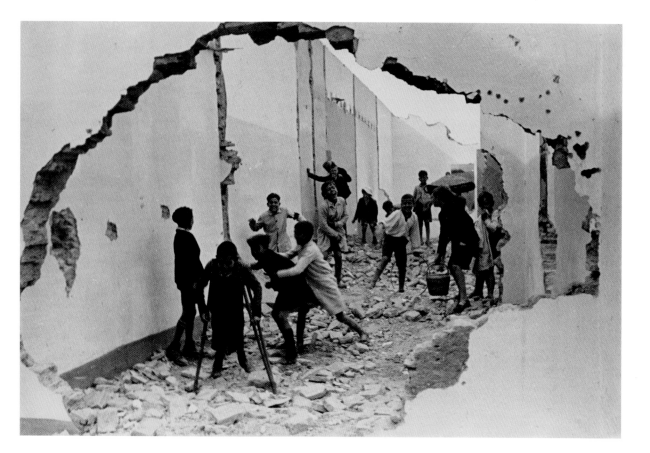

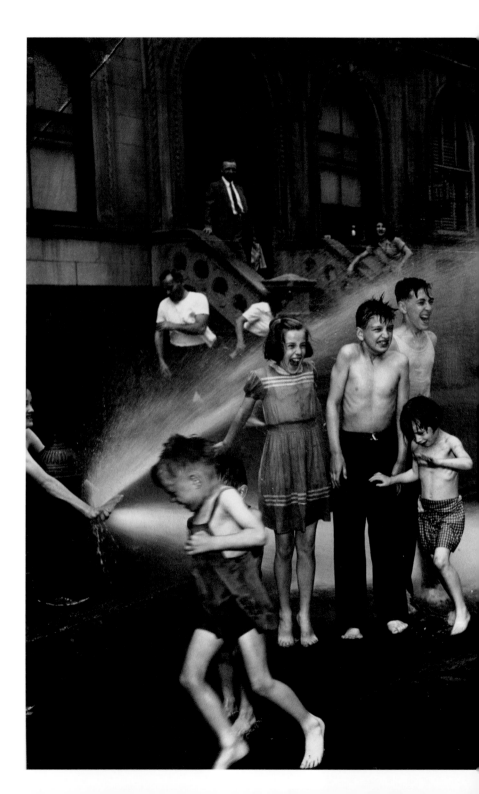

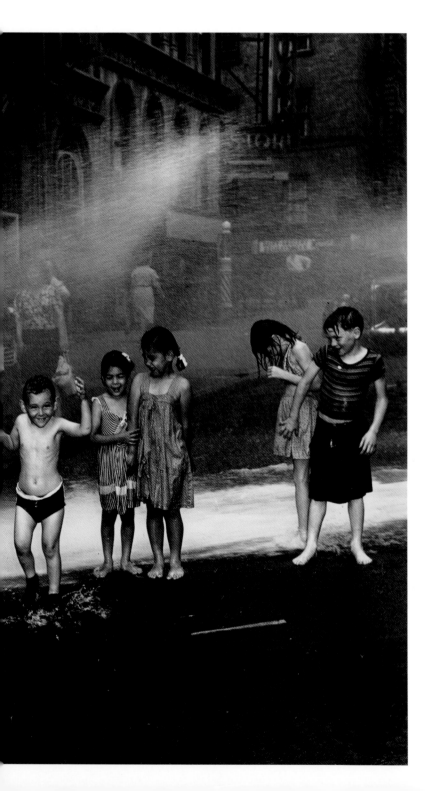

38 **WEEGEE**
Summer, the Lower East Side,
New York, 1937

 39 **WALTER ROSENBLUM**
Street Scene, 105th Street, New York, 1952

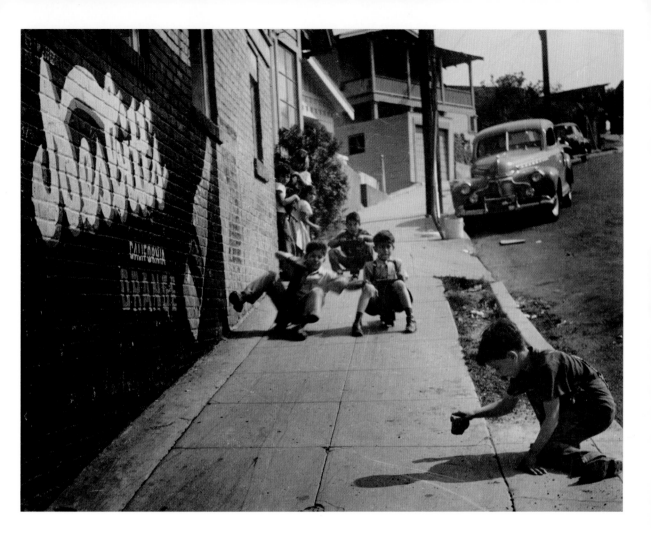

JOE SCHWARTZ
East L.A. Skateboarders, 1950s

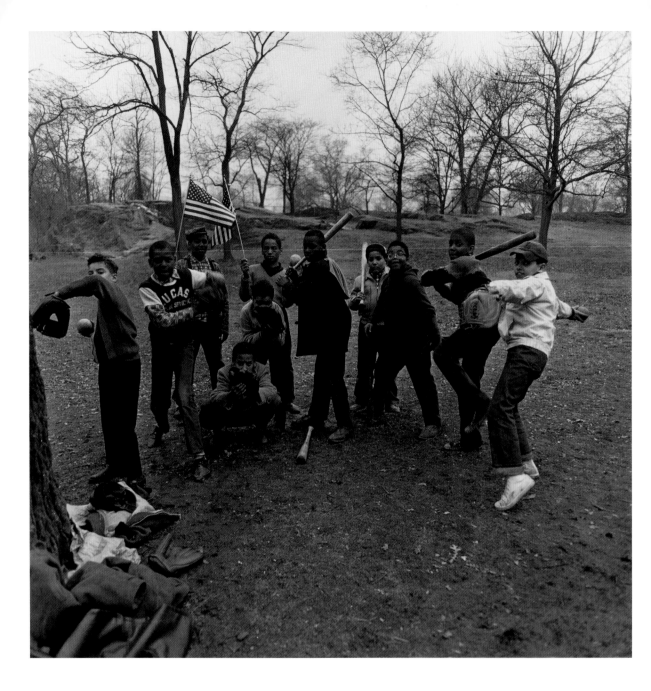

41 **DIANE ARBUS**
Baseball Game in Central Park, New York City, 1962

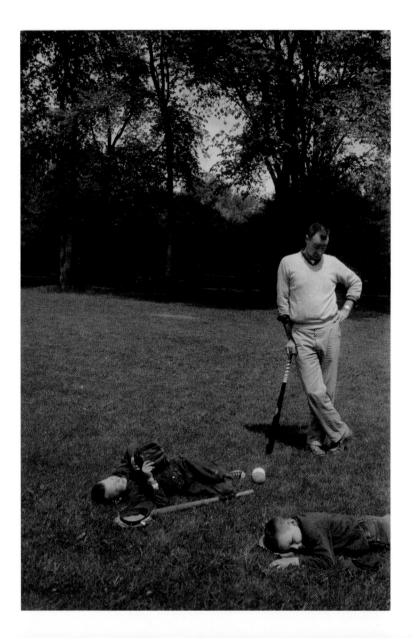

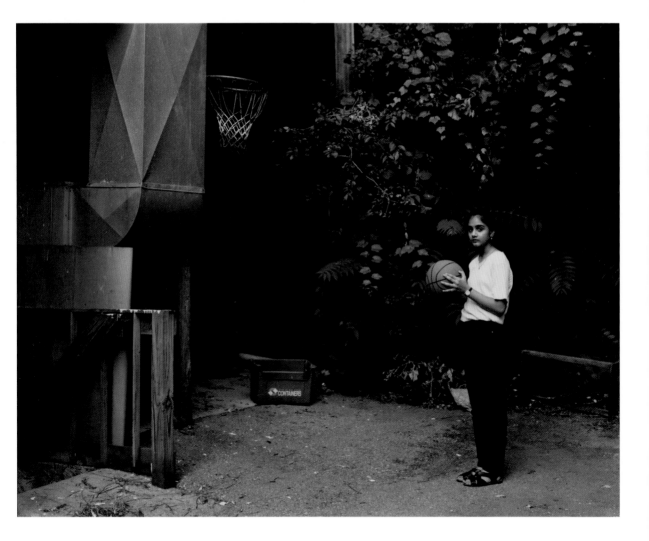

43 JOEL STERNFELD
Untitled (Girl with Basketball), November 11, 1993

44 FERNAND KHNOPFF
Femme à la raquette, dans un jardin
(Woman with Racquet, in a Garden), ca. 1889

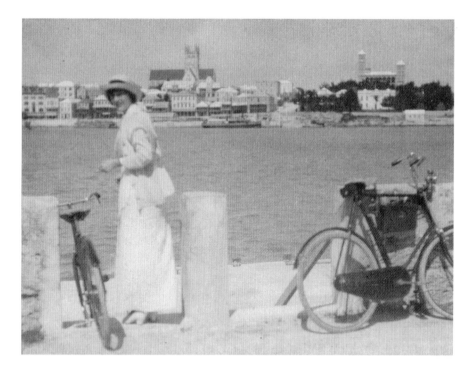

45 **KARL F. STRUSS**
Untitled (Woman with Bicycles), ca. 1910–12

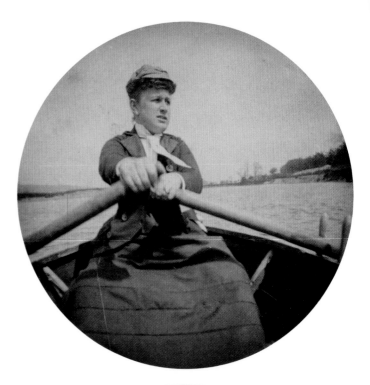

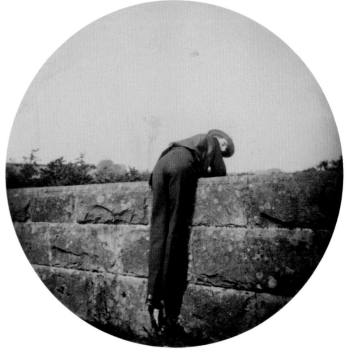

46 UNKNOWN BRITISH
OR AMERICAN PHOTOGRAPHER
Untitled (Woman Rowing a Boat), 1880s–90s

47 UNKNOWN BRITISH
OR AMERICAN PHOTOGRAPHER
Untitled (Man Scaling a Wall), 1880s–90s

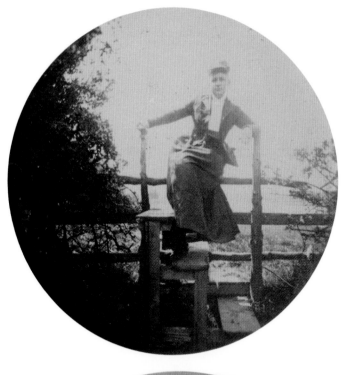

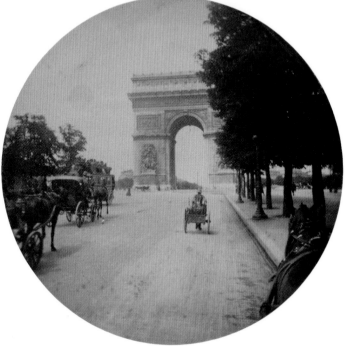

48 **UNKNOWN BRITISH
OR AMERICAN PHOTOGRAPHER**
Untitled (Woman Posed on a Stile), 1880s–90s

49 **UNKNOWN BRITISH
OR AMERICAN PHOTOGRAPHER**
Untitled (Arc de Triomphe, Paris), 1880s–90s

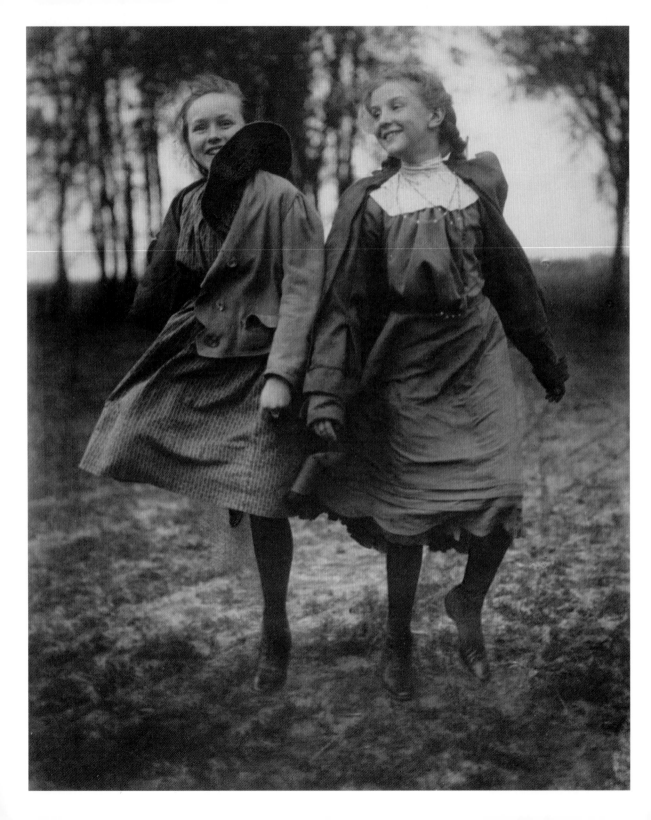

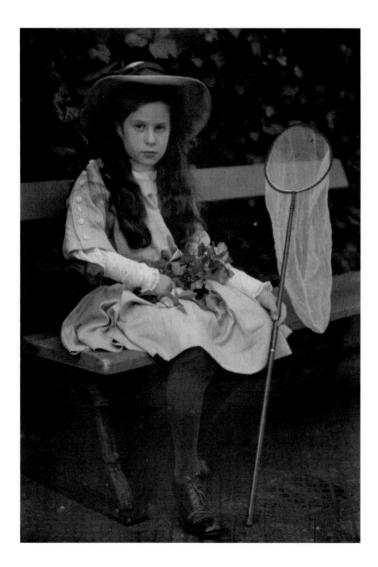

50 **LOUIS FLECKENSTEIN**
A Pastoral, 1905

51 **ALFRED STIEGLITZ**
Untitled (Kitty Stieglitz), 1907

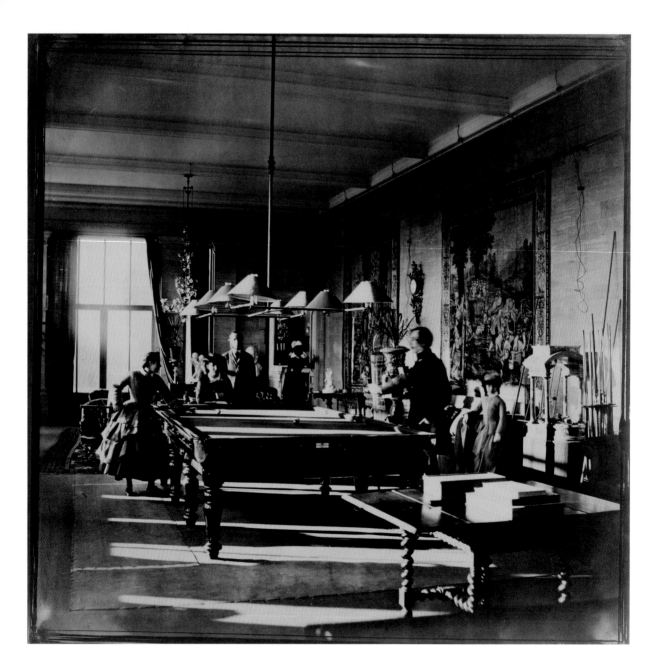

52 **ROGER FENTON**
The Billiard Room, Mentmore House, ca. 1858

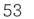
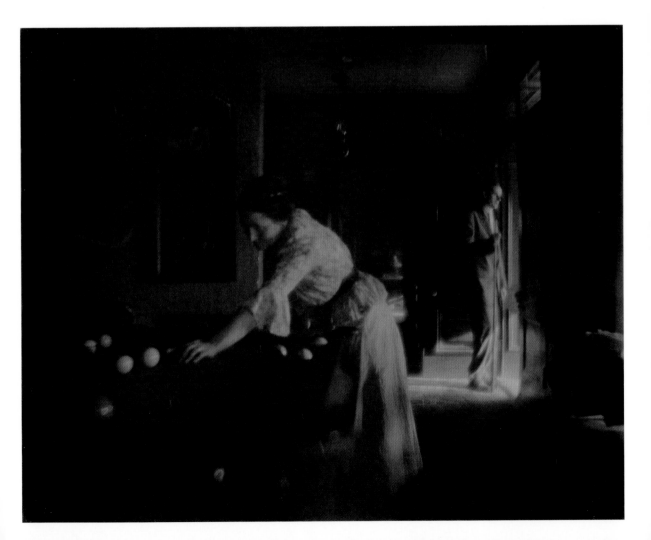

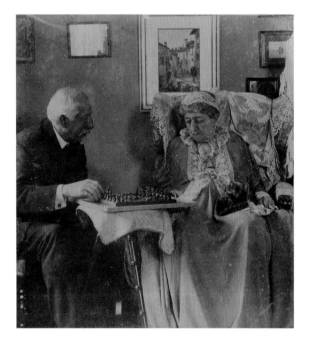

54 **HENRY HERSCHEL HAY CAMERON**
Hardinge Hay Cameron and Lady Dalrymple Playing Chess, 1900

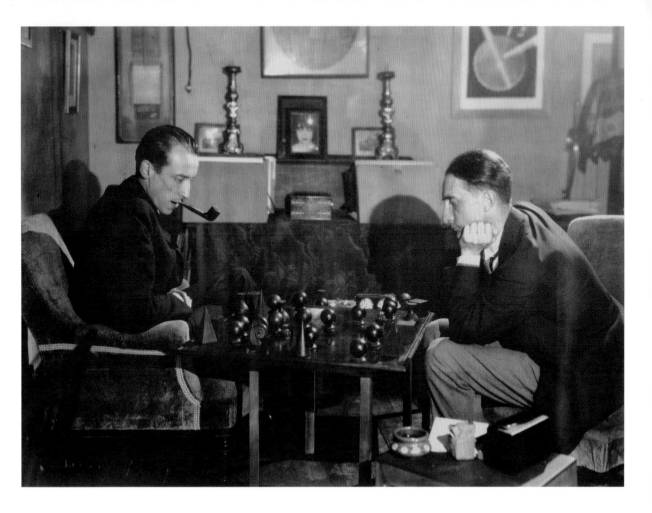

55 **MAN RAY**
Untitled (Marcel Duchamp and Raoul de Roussy
Playing Chess), 1925

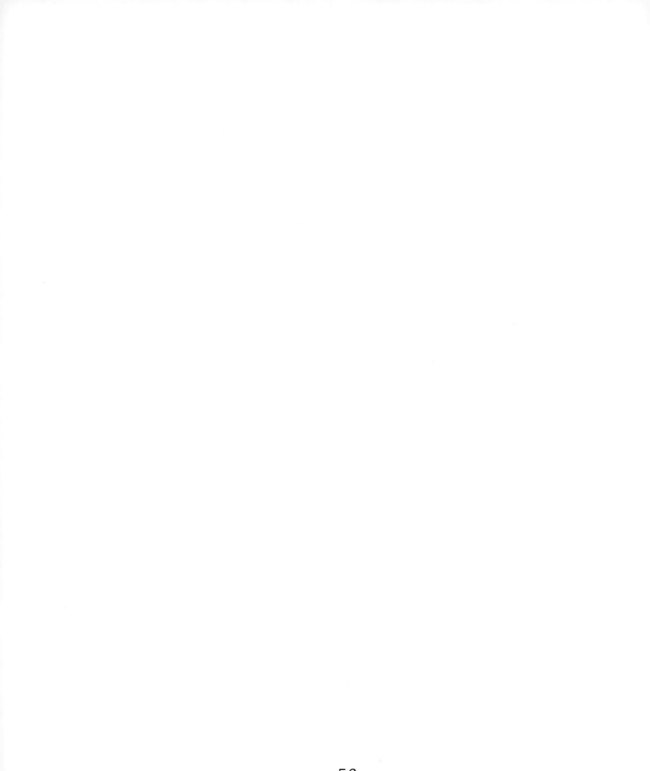

56 **MAX YAVNO**
Card Players, Los Angeles, California, 1949

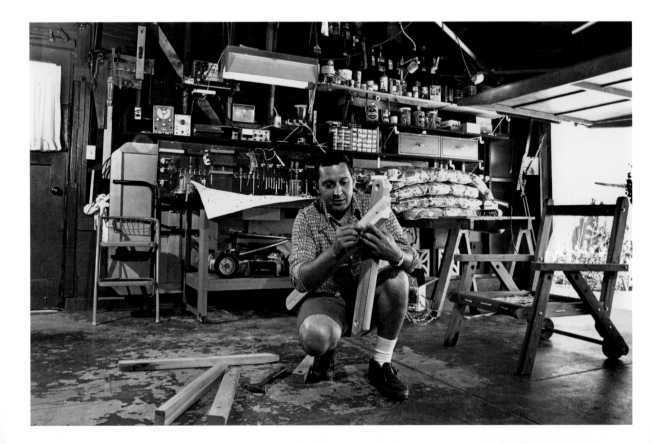

57 **BILL OWENS**
Garage, 1971

58 MILTON ROGOVIN
Working People, Shenango Steel, 1976

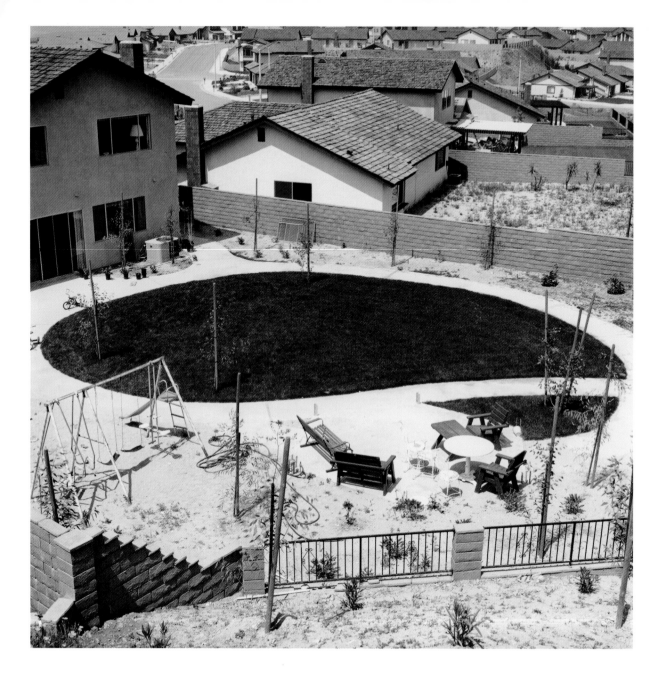

59 **JOE DEAL**
Backyard, Diamond Bar, California, 1980

60 **BILL OWENS**
Sunday Afternoon We Get It Together.
I Cook the Steaks and My Wife Makes the Salad, 1971

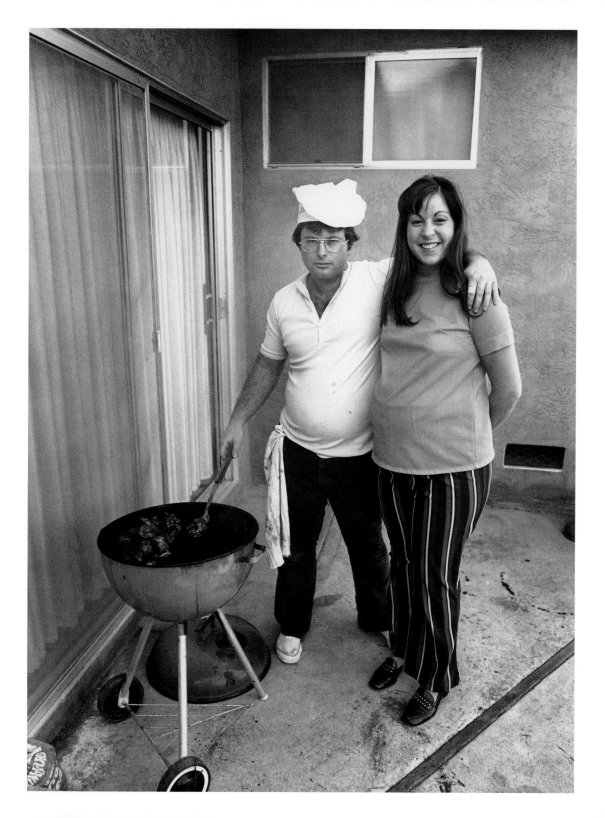

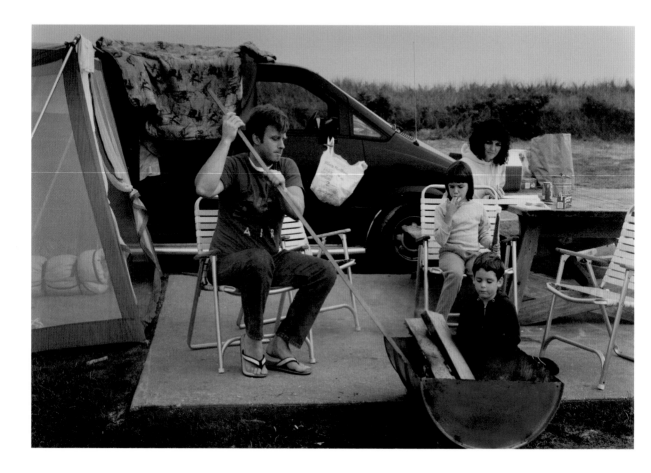

ADAM BARTOS
Hither Hills State Park, Montauk, New York, 1991–94

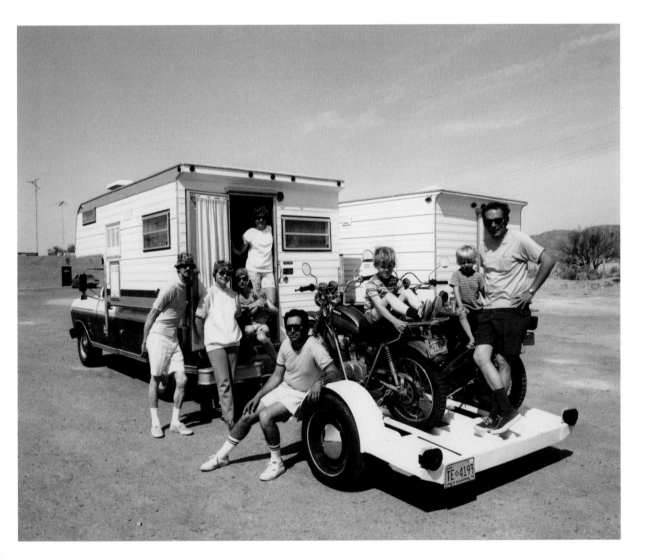

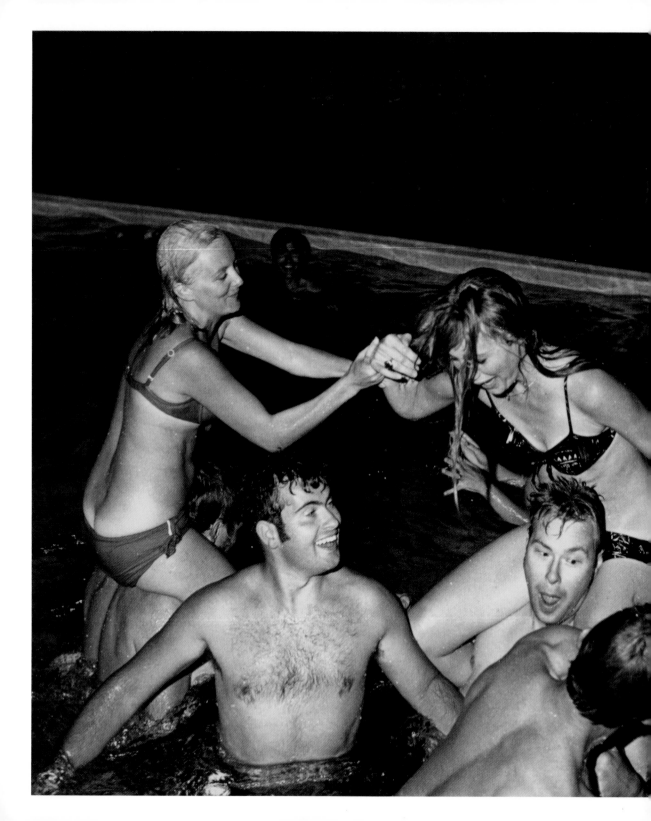

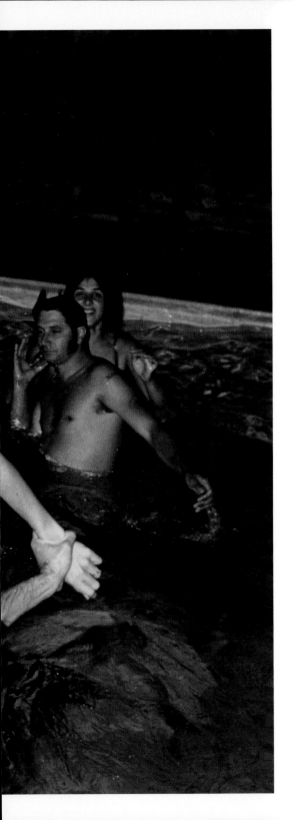

63 **BILL OWENS**
Untitled (Swimming Pool), 1973

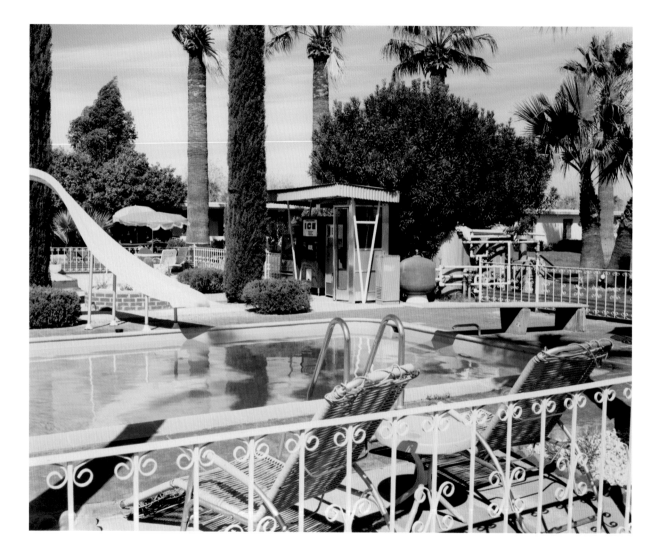

64 WILLIAM LARSON
Untitled (Motel Pool), 1980

65 **LARRY SULTAN**
Untitled, 1979

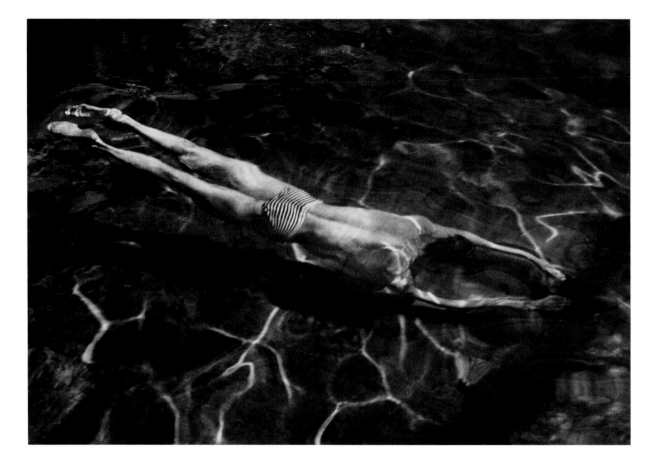

66 **ANDRÉ KERTÉSZ**
Underwater Swimmer, negative, 1917; print, 1970s

67 **EDWARD WESTON**
Bathers, 1919

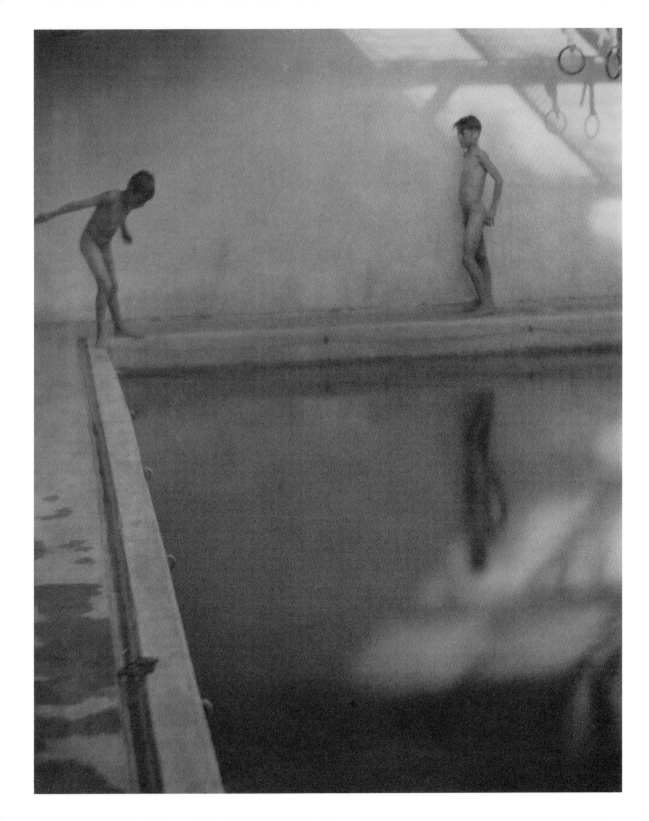

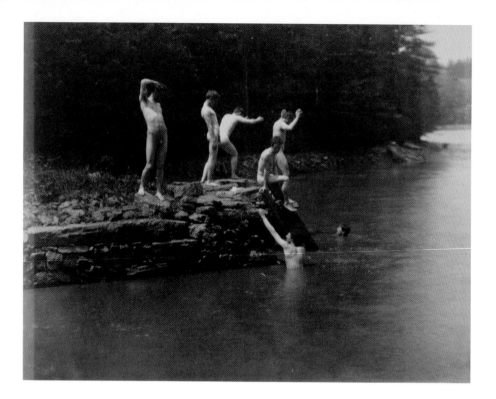

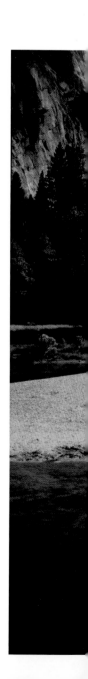

THOMAS EAKINS

Male Figures at the Site of "Swimming," 1884

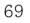 **STEPHEN SHORE**
Merced River, Yosemite National Park, California,
negative, August 13, 1979; print, 1998

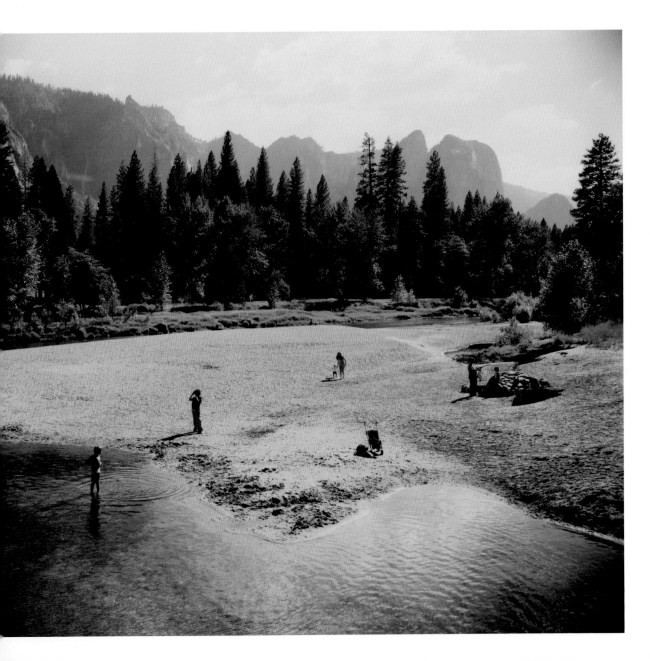

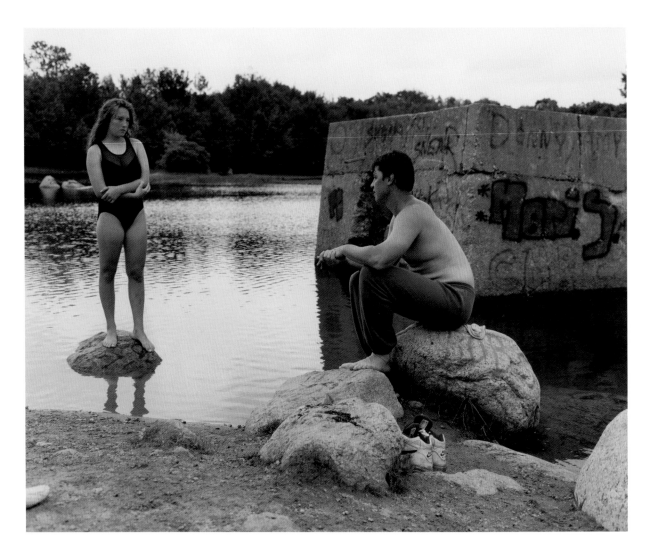

70 **JUSTIN KIMBALL**
East Greenwich, Rhode Island, negative, 1998; print, 2006

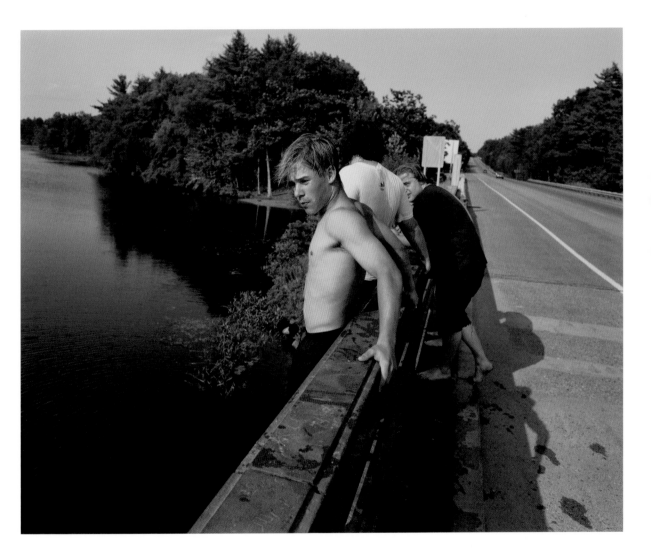

71 JUSTIN KIMBALL
Orange, Massachusetts, negative, 1996; print, 2006

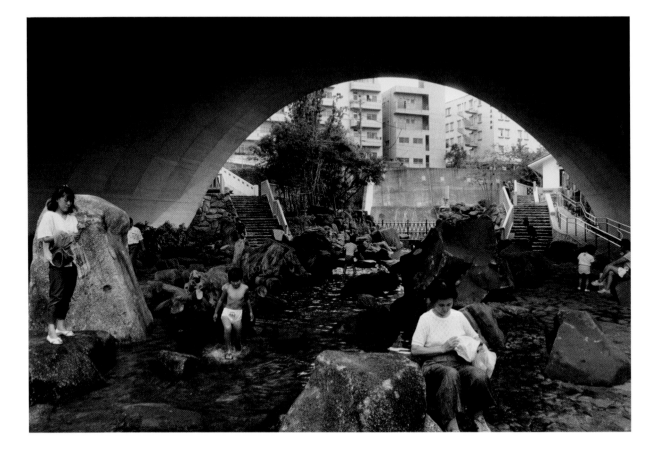

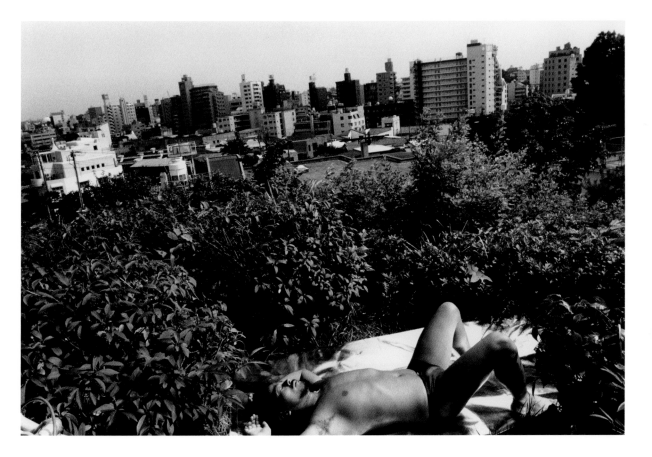

73 SHIGEICHI NAGANO
Tokyo, Aobadai (Nishi Saigoyama Park), Meguro Ward, 1988

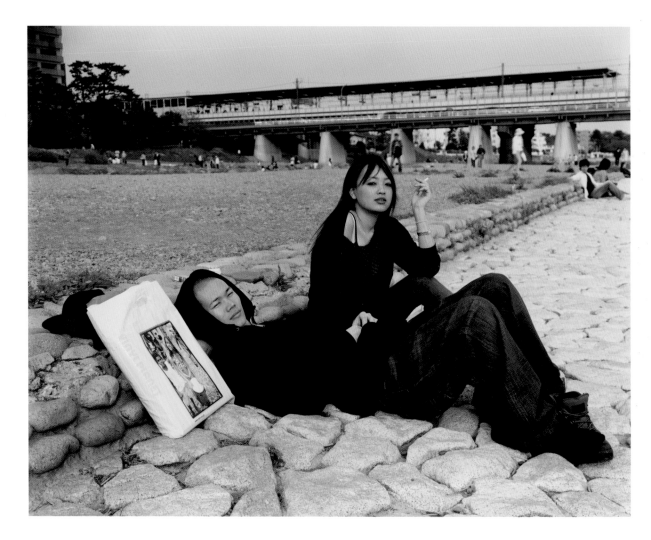

MASATO SETO
Picnic [34], 2005

75 MASATO SETO
Picnic [32], 2005

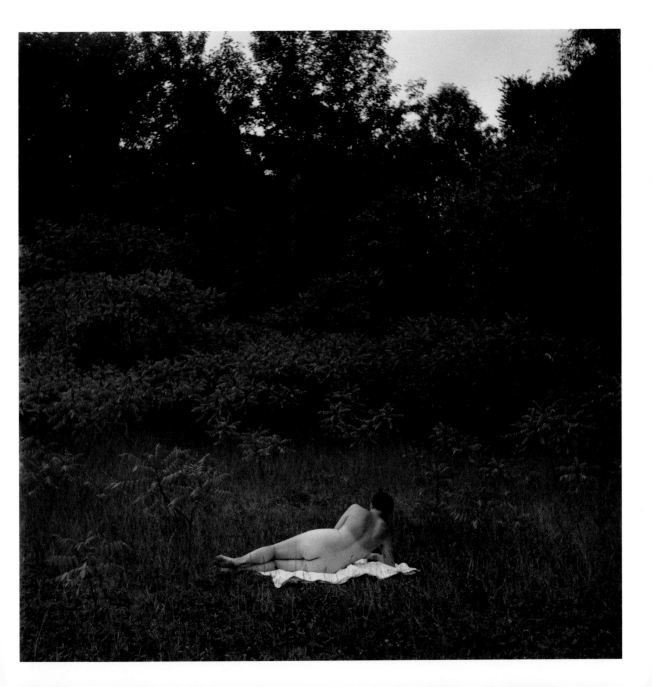

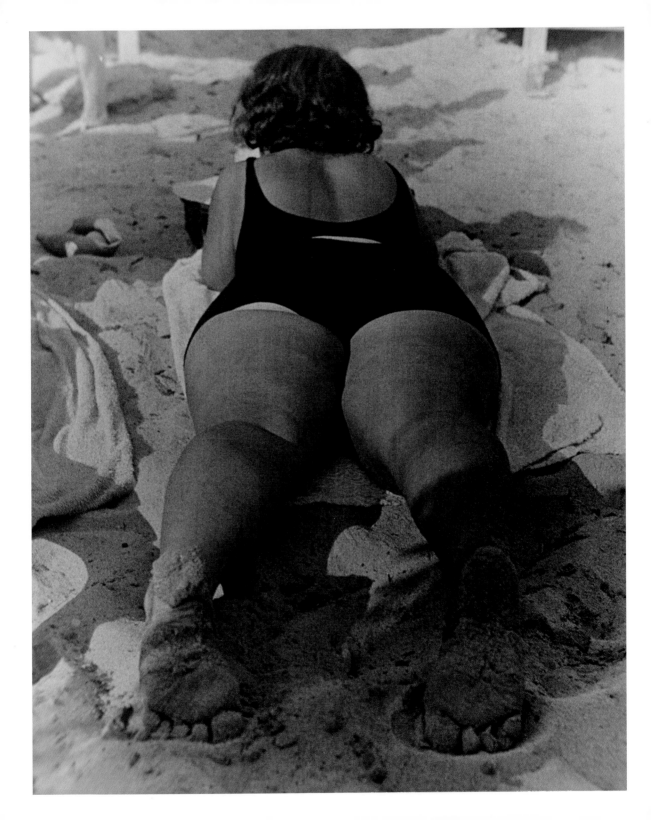

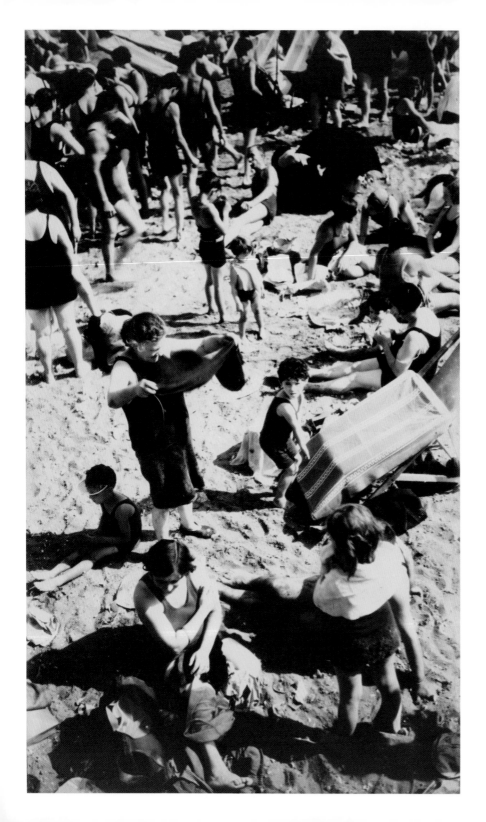

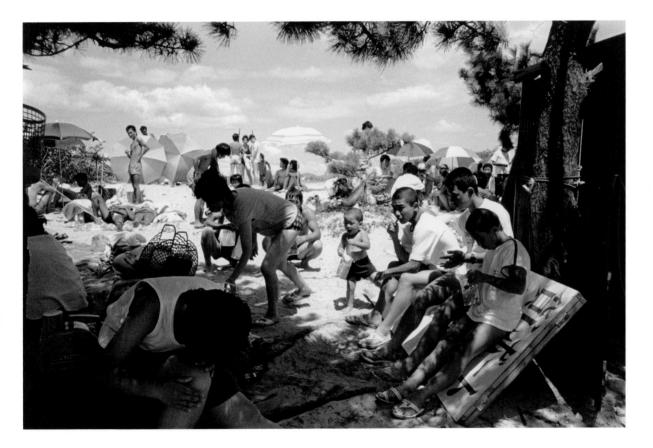

 78 WALKER EVANS
Coney Sands, 1930

 79 HIROMI TSUCHIDA
Counting Grains of Sand, Tsuruga, negative, 1985;
print, May 15, 1990

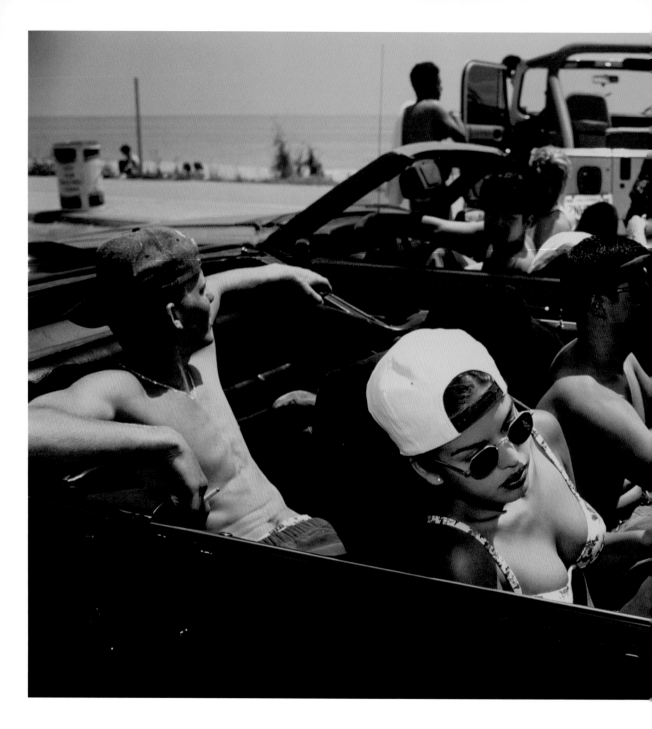

 LAUREN GREENFIELD
Mijanou and Friends from Beverly Hills High School on
Senior Beach Day, Will Rogers State Beach, 1993

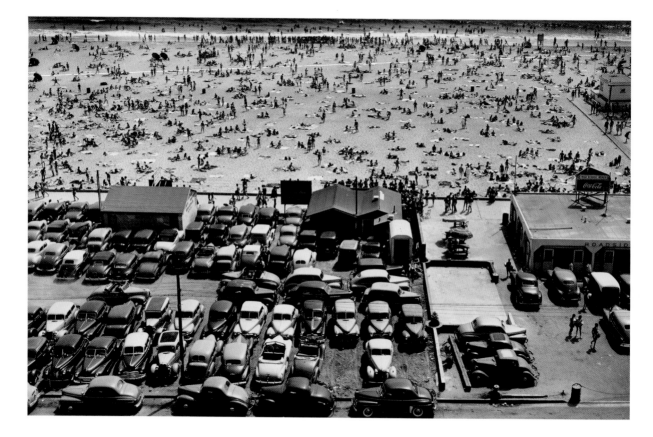

81 **MAX YAVNO**
High School Beach, Los Angeles, 1949

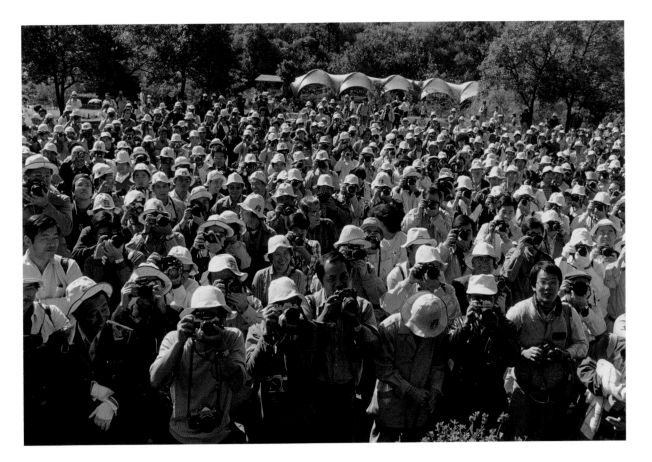

 HIROMI TSUCHIDA
Counting Grains of Sand, Imasaki, negative, 1981;
print, May 15, 1990

Plate List

All photographs are from the collection of the J. Paul Getty Museum, Los Angeles.

1

**ATTRIBUTED TO
HENRY HOLLISTER**
Canadian, active ca. 1840–60
*Untitled (Couple at Niagara Falls
in Waterproof Clothing)*, 1860s
Ambrotype
12.7 × 17.9 cm (5 × 7¹⁄₁₆ in.)
84.XT.818.15

2

ROGER MINICK
American, b. 1944
*Woman with Scarf at Inspiration
Point, Yosemite National Park*,
1980
Sightseer series
Chromogenic print
38.1 × 43.5 cm (15 × 17⅛ in.)
97.XM.38

3

WALKER EVANS
American, 1903–1975
Coney Island Boardwalk, 1929
Gelatin silver print
21.4 × 14.4 cm (8⁷⁄₁₆ × 5⅝ in.)
84.XM.956.462

4

WALKER EVANS
American, 1903–1975
Couple at Coney Island, 1928
Gelatin silver print
18.6 × 15.4 cm (7⁵⁄₁₆ × 6¹⁄₁₆ in.)
84.XM.956.464

5

LOUIS FLECKENSTEIN
American, 1866–1943
Untitled (Carousel), ca. 1910
Gum bichromate print
26.7 × 33.8 cm (10½ × 13⁵⁄₁₆ in.)
85.XM.28.504

6

HANS VOLLHARDT
German, active 1920s
*Untitled (Mirror Distortion with
Students and Camera)*, ca. 1929
Gelatin silver print
7.6 × 10.6 cm (3 × 4³⁄₁₆ in.)
85.XP.384.60

7

HANS VOLLHARDT
German, active 1920s
*Untitled (Mirror Distortion with
Four Students and Camera)*,
ca. 1929
Gelatin silver print
7.6 × 10.6 cm (3 × 4³⁄₁₆ in.)
85.XP.384.59

8

CHARLES DUDLEY ARNOLD
American, born Canada,
1844–1927
*Captive Balloon and Ferris Wheel,
World Columbian Exposition,
Chicago*, 1892–93
Gelatin silver print
18.1 × 21.6 cm (7⅛ × 8½ in.)
84.XP.1438.9

9

BRASSAÏ (GYULA HALÁSZ)
French, born Hungary, 1899–1984
*Balloon Seller, Montsouris Park,
Paris*, negative, 1931; print, 1934
Gelatin silver print
49.1 × 40 cm (19⁵⁄₁₆ × 15¾ in.)
86.XM.3.9

10

MARTIN MUNKACSI
American, born Hungary,
1896–1963
Kettenkarussel (Swing Carousel),
1928
Gelatin silver print
29.4 × 23.5 cm (11⁹⁄₁₆ × 9¼ in.)
84.XM.203.1

11

BRASSAÏ (GYULA HALÁSZ)
French, born Hungary, 1899–1984
Kiss on the Swing, Paris, 1935–37
Gelatin silver print
29.7 × 23.3 cm (11¹¹⁄₁₆ × 9³⁄₁₆ in.)
84.XM.1024.18

12

EUGÈNE ATGET
French, 1857–1927
Fête du Trône (Street Fair), 1923
Albumen silver print
17.8 × 22.5 cm (7 × 8⅞ in.)
90.XM.64.185

13

EUGÈNE ATGET
French, 1857–1927
*Guignol, Jardin du Luxembourg
(Puppet Show, Luxembourg
Gardens)*, 1898
Albumen silver print
17.8 × 22.2 cm (7 × 8¾ in.)
90.XM.64.75

14

COUNT DE MONTIZON
Spanish, 1822–1887
*The Hippopotamus at the
Zoological Gardens, Regent's Park*,
1852
Salted paper print from a wet
collodion negative
11.4 × 12.5 cm (4½ × 4¹⁵⁄₁₆ in.)
84.XA.871.6.9

15

GARRY WINOGRAND
American, 1928–1984
*Miss Liberty, Circle Line, Hudson
River, New York*, 1971
Gelatin silver print
22.5 × 34.1 cm (8⅞ × 13⁷⁄₁₆ in.)
84.XM.1023.2

16

GARRY WINOGRAND
American, 1928–1984
World's Fair, New York City, 1964
Gelatin silver print
22.7 × 34.3 cm (8¹⁵⁄₁₆ × 13½ in.)
84.XM.1023.17

17

HENRI CARTIER-BRESSON
French, 1908–2004
The Baseball Fever, 1957
Gelatin silver print
25.3 × 16.9 cm (9¹⁵⁄₁₆ × 6⅝ in.)
2004.74.9

18

WEEGEE (ARTHUR FELLIG)
American, born Austria, 1899–1968
Audience in the Palace Theatre,
ca. 1953
Gelatin silver print
26.2 × 33.7 cm (10⁵⁄₁₆ × 13¼ in.)
86.XM.4.10

19

HENRI CARTIER-BRESSON
French, 1908–2004
*Horse Racing at Miami's Hialeah
Race Track*, 1957
Gelatin silver print
16.5 × 25 cm (6½ × 9¹³⁄₁₆ in.)
2004.74.2

20

LISETTE MODEL
American, born Austria, 1901–1983
*Belmont Park Race Track,
Couple with Cigarettes*, 1956
Gelatin silver print
24.9 × 20 cm (9¹³⁄₁₆ × 7⅞ in.)
2004.62.3

21

CAMILLE SILVY
French, 1834–1910
Untitled, 1864
From the album *Orléans House,
Fête Champêtre*
Carbon print
10 × 16.5 cm (3¹⁵⁄₁₆ × 6½ in.)
84.XO.607.6

22

EDWARD STEICHEN
American, 1879–1973
*Grand Prix at Longchamp,
After the Races*, 1907
Gelatin silver print
18.6 × 20.1 cm (7⁵⁄₁₆ × 7⅞ in.)
84.XM.157.6

23

GARRY WINOGRAND
American, 1928–1984
*Centennial Ball, Metropolitan
Museum, New York*, 1969
Gelatin silver print
22.2 × 33.2 cm (8¾ × 13¹⁄₁₆ in.)
2004.50.4

24

WEEGEE (ARTHUR FELLIG)
American, born Austria, 1899–1968
The Body Beautiful / Celebrating,
November 1943
Gelatin silver print
26.7 × 27.1 cm (10½ × 10¹¹⁄₁₆ in.)
86.XM.4.5

25

WEEGEE (ARTHUR FELLIG)
American, born Austria, 1899–1968
San Remo, ca. 1945
Gelatin silver print
22.6 × 19.6 cm (8⅞ × 7¹¹⁄₁₆ in.)
2003.99.4

26

BILL BRANDT
English, born Germany, 1904–1983
*In a London Bar (At Charlie
Brown's, Limehouse)*, 1945
Gelatin silver print
23.2 × 19.7 cm (9⅛ × 7¾ in.)
89.XM.60.1

27

DAVID OCTAVIUS HILL
Scottish, 1802–1870
ROBERT ADAMSON
Scottish, 1821–1848
Edinburgh Ale, 1843–47
Salted paper print from a calotype
negative
14.6 × 19.7 cm (5¾ × 7¾ in.)
84.XO.734.4.5.18

28

MILTON ROGOVIN
American, 1909–2011
Lower West Side, 1973
Gelatin silver print
17.5 × 18.1 cm (6⅞ × 7⅛ in.)
97.XM.43.16.1

29

PAUL WOLFF
German, 1887–1951
Couple Dancing, 1940s
Gelatin silver print
23.8 × 17.9 cm (9⅜ × 7¹⁄₁₆ in.)
84.XM.139.138

30

BRASSAÏ (GYULA HALÁSZ)
French, born Hungary, 1899–1984
Two Butchers Dancing, Paris,
ca. 1931
Gelatin silver print
29.4 × 23 cm (11⁹⁄₁₆ × 9¹⁄₁₆ in.)
84.XM.1024.6

31

ANDRÉ KERTÉSZ
American, born Hungary,
1894–1985
Swimming Pool and Dance Floor,
1930
Gelatin silver print
22.5 × 16.7 cm (8⅞ × 6⁹⁄₁₆ in.)
84.XM.193.57

32

ANDRÉ KERTÉSZ
American, born Hungary,
1894–1985
Untitled (Sari Dienes and Friends),
1930
Gelatin silver print
17.9 × 24 cm (7¹⁄₁₆ × 9⁷⁄₁₆ in.)
84.XM.193.52

33

LOUIS FLECKENSTEIN
American, 1866–1943
*Untitled (Women with Cameras at
the Base of a Tree)*, ca. 1900
Gelatin silver print
20.5 × 25.6 cm (8¹⁄₁₆ × 10¹⁄₁₆ in.)
85.XM.28.590

34

T. LUX FEININGER
American, born Germany,
1910–2011
*Untitled (Georg Hartmann with
Karla Grosch on His Shoulders
outside the Bauhaus)*, 1929
Gelatin silver print
11.4 × 8.3 cm (4½ × 3¼ in.)
85.XP.260.185

35

T. LUX FEININGER
American, born Germany,
1910–2011
*Untitled (Two Members of the
Bauhaus Band Playing the
Banjo and Clarinet)*, ca. 1928
Gelatin silver print
8.3 × 11.4 cm (3¼ × 4½ in.)
85.XP.384.93

36

EUGÈNE ATGET
French, 1857–1927
*Women and Children in the
Luxembourg Gardens*, 1898
Albumen silver print
17.6 × 22.5 cm (6¹⁵⁄₁₆ × 8⅞ in.)
90.XM.64.78

37

HENRI CARTIER-BRESSON
French, 1908–2004
Seville, Spain, negative, 1933;
print, ca. 1935
Gelatin silver print
19.4 × 28.9 cm (7⅝ × 11⅜ in.)
84.XM.1008.5

38

WEEGEE (ARTHUR FELLIG)
American, born Austria, 1899–1968
*Summer, the Lower East Side,
New York*, 1937
Gelatin silver print
26.5 × 33.3 cm (10⁷⁄₁₆ × 13⅛ in.)
84.XM.190.2

39

WALTER ROSENBLUM
American, 1919–2006
*Street Scene, 105th Street,
New York*, 1952
Gelatin silver print
17 × 24.1 cm (6¹¹⁄₁₆ × 9½ in.)
2000.18.4

40

JOE SCHWARTZ
American, b. 1913
East L.A. Skateboarders, 1950s
Gelatin silver print
30.2 × 39 cm (11⅞ × 15⅜ in.)
2004.53.2

41

DIANE ARBUS
American, 1923–1971
*Baseball Game in Central Park,
New York City*, 1962
Gelatin silver print
22.5 × 22 cm (8⅞ × 8¹¹⁄₁₆ in.)
2001.2

42

HENRI CARTIER-BRESSON
French, 1908–2004
*Baseball Is an Integral Part of
Family Life*, 1957
Gelatin silver print
25.4 × 16.9 cm (10 × 6⅝ in.)
2004.74.38

43

JOEL STERNFELD
American, b. 1944
Untitled (Girl with Basketball),
November 11, 1993
Chromogenic print
19.7 × 24.6 cm (7¾ × 9¹¹⁄₁₆ in.)
Gift of Nancy and Bruce Berman
2002.76.2

44

FERNAND KHNOPFF
Belgian, 1858–1921
*Femme à la raquette, dans
un jardin (Woman with Racquet,
in a Garden)*, ca. 1889
Gelatin silver print
16.6 × 11.7 cm (6⁹⁄₁₆ × 4⅝ in.)
2004.90.2

45

KARL F. STRUSS
American, 1886–1981
Untitled (Woman with Bicycles),
ca. 1910–12
Platinum print
8 × 10.6 cm (3⅛ × 4³⁄₁₆ in.)
84.XM.189.33

46

**UNKNOWN BRITISH OR AMERICAN
PHOTOGRAPHER**
Untitled (Woman Rowing a Boat),
1880s–90s
Albumen silver print
Diam: 6 cm (2⅜ in.)
84.XA.736.10.59

47

**UNKNOWN BRITISH OR AMERICAN
PHOTOGRAPHER**
Untitled (Man Scaling a Wall),
1880s–90s
Albumen silver print
Diam: 6 cm (2⅜ in.)
84.XA.736.10.63

48

**UNKNOWN BRITISH OR AMERICAN
PHOTOGRAPHER**
Untitled (Woman Posed on a Stile),
1880s–90s
Albumen silver print
Diam: 6 cm (2⅜ in.)
84.XA.736.10.68

49

**UNKNOWN BRITISH OR AMERICAN
PHOTOGRAPHER**
Untitled (Arc de Triomphe, Paris),
1880s–90s
Albumen silver print
Diam: 6 cm (2⅜ in.)
84.XA.736.10.33

50

LOUIS FLECKENSTEIN
American, 1866–1943
A Pastoral, 1905
Gelatin silver print
41.3 × 34.3 cm (16¼ × 13½ in.)
85.XM.315.9

51

ALFRED STIEGLITZ
American, 1864–1946
Untitled (Kitty Stieglitz), 1907
Autochrome
14.3 × 9.8 cm (5⅝ × 3⅞ in.)
85.XH.151.5

52

ROGER FENTON
English, 1819–1869
*The Billiard Room,
Mentmore House,* ca. 1858
Albumen silver print
30.3 × 30.6 cm (11¹⁵⁄₁₆ × 12¹⁄₁₆ in.)
2001.27

53

GERTRUDE KÄSEBIER
American, 1852–1934
*Untitled (Gertrude Käsebier
O'Malley at Billiards),* ca. 1909
Platinum print
19.5 × 24.6 cm (7¹¹⁄₁₆ × 9¹¹⁄₁₆ in.)
87.XM.59.11

54

HENRY HERSCHEL HAY CAMERON
English, 1856–1911
*Hardinge Hay Cameron and Lady
Dalrymple Playing Chess,* 1900
Albumen silver print
8.1 × 7.5 cm (3³⁄₁₆ × 2¹⁵⁄₁₆ in.)
86.XM.637.3

55

MAN RAY
American, 1890–1976
*Untitled (Marcel Duchamp and
Raoul de Roussy Playing Chess),*
1925
Gelatin silver print
16.7 × 22.5 cm (6⁹⁄₁₆ × 8⅞ in.)
84.XM.1000.138

56

MAX YAVNO
American, 1911–1985
*Card Players, Los Angeles,
California,* 1949
Gelatin silver print
26.5 × 27.9 cm (10⁷⁄₁₆ × 11 in.)
Gift of Nancy and Bruce Berman
99.XM.87.2

57

BILL OWENS
American, b. 1938
Garage, 1971
Gelatin silver print
13.9 × 21.5 cm (5½ × 8⁷⁄₁₆ in.)
Purchased in part with funds pro-
vided by the Photographs Council
2005.36.4

58

MILTON ROGOVIN
American, 1909–2011
*Working People,
Shenango Steel,* 1976
From the triptych *Working
People, Shenango Steel*
Gelatin silver print
17.9 × 16.4 cm (7¹⁄₁₆ × 6⁷⁄₁₆ in.)
97.XM.43.25.2

59

JOE DEAL
American, 1947–2010
*Backyard, Diamond Bar,
California,* 1980
Gelatin silver print
28.4 × 28.6 cm (11³⁄₁₆ × 11¼ in.)
2008.57.10

60

BILL OWENS
American, b. 1938
*Sunday Afternoon We Get It
Together. I Cook the Steaks and
My Wife Makes the Salad,* 1971
Gelatin silver print
30.6 × 22.9 cm (12¹⁄₁₆ × 9 in.)
Purchased in part with funds
provided by the Photographs Council
2005.36.1

61

ADAM BARTOS
American, b. 1953
*Hither Hills State Park, Montauk,
New York,* 1991–94
Chromogenic print
49.1 × 72.4 cm (19⁵⁄₁₆ × 28½ in.)
Gift of Nancy and Bruce Berman
98.XM.199.5

62

BILL OWENS
American, b. 1938
*On Weekends We Camp
and Ride Dirt Bikes,* 1976
Gelatin silver print
19.2 × 23.3 cm (7⁹⁄₁₆ × 9³⁄₁₆ in.)
Purchased in part with funds pro-
vided by the Photographs Council
2005.36.14

63

BILL OWENS
American, b. 1938
Untitled (Swimming Pool), 1973
Gelatin silver print
17.1 × 21.5 cm (6¾ × 8⁷⁄₁₆ in.)
Gift of Robert Harshorn Shimshak
and Marion Brenner
2007.56.11

64

WILLIAM LARSON
American, b. 1942
Untitled (Motel Pool), 1980
Chromogenic print
45.4 × 55.9 cm (17⅞ × 22 in.)
Gift of Nancy and Bruce Berman
98.XM.221

65

LARRY SULTAN
American, 1946–2009
Untitled, 1979
The Swimmers series
Chromogenic print
32.4 × 47.9 cm (12¾ × 18⅞ in.)
84.XP.457.15

66

ANDRÉ KERTÉSZ
American, born Hungary,
1894–1985
Underwater Swimmer,
negative, 1917; print, 1970s
Gelatin silver print
17 × 24.7 cm (6¹¹⁄₁₆ × 9¾ in.)
84.XM.193.11

67

EDWARD WESTON
American, 1886–1958
Bathers, 1919
Platinum print
24.1 × 19.2 cm (9½ × 7⁹⁄₁₆ in.)
85.XM.257.1

68

THOMAS EAKINS
American, 1844–1916
*Male Figures at the
Site of "Swimming,"* 1884
Albumen silver print
9.3 × 12.1 cm (3¹¹⁄₁₆ × 4¹³⁄₁₆ in.)
84.XM.811.1

69

STEPHEN SHORE
American, b. 1947
Merced River, Yosemite National Park, California, negative, August 13, 1979; print, 1998
Chromogenic print
20.5 × 25.4 cm (8 1/16 × 10 in.)
Gift of Nancy and Bruce Berman
99.XM.84.3

70

JUSTIN KIMBALL
American, b. 1961
East Greenwich, Rhode Island, negative, 1998; print, 2006
Where We Find Ourselves series
Chromogenic print
44.8 × 55.7 cm (17 5/8 × 21 15/16 in.)
Gift of Jeanne and Richard S. Press
2008.64.4

71

JUSTIN KIMBALL
American, b. 1961
Orange, Massachusetts, negative, 1996; print, 2006
Where We Find Ourselves series
Chromogenic print
45 × 55.9 cm (17 11/16 × 22 in.)
Gift of Jeanne and Richard S. Press
2008.64.3

72

SHIGEICHI NAGANO
Japanese, b. 1925
Tokyo, Shakuji River, Kita Ward, 1988
Gelatin silver print
26 × 39.2 cm (10 1/4 × 15 7/16 in.)
Purchased with funds provided by the Photographs Council
2008.11.2

73

SHIGEICHI NAGANO
Japanese, b. 1925
Tokyo, Aobadai (Nishi Saigoyama Park), Meguro Ward, 1988
Gelatin silver print
26 × 39.4 cm (10 1/4 × 15 1/2 in.)
Purchased with funds provided by the Photographs Council
2008.11.1

74

MASATO SETO
Japanese, born Thailand, 1953
Picnic [34], 2005
Chromogenic print
43 × 54.5 cm (16 15/16 × 21 7/16 in.)
Purchased with funds provided by the Photographs Council
2006.34.7

75

MASATO SETO
Japanese, born Thailand, 1953
Picnic [32], 2005
Chromogenic print
43.2 × 55 cm (17 × 21 5/8 in.)
Purchased with funds provided by the Photographs Council
2006.34.6

76

HARRY CALLAHAN
American, 1912–1999
Eleanor, Port Huron, negative, 1954; print, ca. 1967
Gelatin silver print
18.3 × 17.7 cm (7 3/16 × 6 15/16 in.)
Anonymous gift
2000.80

77

LISETTE MODEL
American, born Austria, 1901–1983
Untitled (Bather, Promenade des Anglais, Nice), 1933–38
Gelatin silver print
28.9 × 23 cm (11 3/8 × 9 1/16 in.)
84.XM.153.53

78

WALKER EVANS
American, 1903–1975
Coney Sands, 1930
Gelatin silver print
33.7 × 21 cm (13 1/4 × 8 1/4 in.)
84.XM.956.13

79

HIROMI TSUCHIDA
Japanese, b. 1939
Counting Grains of Sand, Tsuruga, negative, 1985; print, May 15, 1990
Gelatin silver print
28.1 × 42.5 cm (11 1/16 × 16 3/4 in.)
2010.7.16

80

LAUREN GREENFIELD
American, b. 1966
Mijanou and Friends from Beverly Hills High School on Senior Beach Day, Will Rogers State Beach, 1993
Dye destruction print
50.8 × 76.8 cm (20 × 30 1/4 in.)
Gift of Allison Amon & Lisa Mehling
2010.84.24

81

MAX YAVNO
American, 1911–1985
High School Beach, Los Angeles, 1949
Gelatin silver print
22.1 × 34.4 cm (8 11/16 × 13 9/16 in.)
Gift of Marjorie and Leonard Vernon
96.XM.340.6

82

HIROMI TSUCHIDA
Japanese, b. 1939
Counting Grains of Sand, Imasaki, negative, 1981; print, May 15, 1990
Gelatin silver print
30 × 44.1 cm (11 13/16 × 17 3/8 in.)
2010.7.15

© 2012 J. Paul Getty Trust

Published by the J. Paul Getty Museum, Los Angeles
Getty Publications
1200 Getty Center Drive, Suite 500
Los Angeles, California 90049-1682
www.getty.edu/publications

Dinah Berland, *Editor*
Jeffrey Cohen, *Designer*
Stacy Miyagawa, *Production Coordinator*
Anne M. Lyden, *Curatorial Coordinator*

Printed in China

Library of Congress Cataloging-in-Publication Data
Garcia, Erin C.
 Photography and play / Erin C. Garcia.
 p. cm.
 ISBN 978-1-60606-107-7 (hardcover)
1. Photography, Artistic. 2. Play—Pictorial works.
3. Recreation—Pictorial works. 4. Photography—History.
I. J. Paul Getty Museum. II. Title.
TR642.G373 2012
779—dc23
 2011038129

FRONT JACKET: Weegee (Arthur Fellig), *Summer, the Lower East Side, New York* (detail, plate 38), 1937
BACK JACKET: Adam Bastos, *Hither Hills State Park, Montauk, New York* (plate 61), 1991–94
PAGE 1: Martin Munkacsi, *Swing Carousel* (detail, plate 10), 1928
PAGES 2–3: Larry Sultan, *Untitled* (detail, plate 65), 1979
PAGE 4: Stephen Shore, *Merced River, Yosemite National Park, California* (detail, plate 69), negative, August 13, 1979; print 1998
PAGE 16: David Octavius Hill and Robert Adamson, *Edinburgh Ale* (detail, plate 27), 1843–47

Illustration Credits
Every effort has been made to contact the owners and photographers of objects reproduced here whose names do not appear in the captions or in the illustration credits listed here. Anyone having further information concerning copyright holders is asked to contact Getty Publications so this information can be included in future printings.

Plate 2: © Roger Minick
Plates 9, 11, 30: © Estate Brassaï / RMN
Plate 10: © Estate of Martin Munkacsi, Courtesy Howard Greenberg Gallery, NYC
Plates 15, 16, 23: © 1984 The Estate of Garry Winogrand
Plates 17, 19, 37, 42: © Henri Cartier-Bresson / Magnum Photos
Plates 18, 24, 25, 38: © Weegee (Arthur Fellig) / International Center of Photography / Getty Images
Plates 20, 77: © Estate of Lisette Model, Courtesy Baudoin Lebon / Keitelman
Plates 28, 58: © Milton Rogovin
Plates 31, 32, 66: © Estate of André Kertész
Plate 39: © Walter Rosenblum
Plate 40: © Joe Schwartz
Plate 41: © Estate of Diane Arbus, LLC
Plate 43: © Joel Sternfeld, Courtesy Luhring Augustine, New York
Plate 45: © 1983 Amon Carter Museum of American Art, Fort Worth, Texas
Plate 51: © 2011 Georgia O'Keeffe Museum / Artists Rights Society (ARS), New York
Plate 55: © Man Ray Trust ARS-ADAGP
Plate 56: Collection Center for Creative Photography, University of Arizona © 1998 The University of Arizona Foundation
Plates 57, 60, 62, 63: © Bill Owens
Plate 59: © Joe Deal
Plate 61: © Adam Bartos
Plate 64: © William Larson
Plate 65: © Estate of Larry Sultan
Plate 67: Collection Center for Creative Photography © 1981 Arizona Board of Regents
Plate 69: © Stephen Shore
Plates 70, 71: © Justin Kimball
Plates 72, 73: © Shigeichi Nagano
Plates 74, 75: © Masato Seto
Plate 76: © The Estate of Harry Callahan, Courtesy Pace / MacGill Gallery, New York
Plate 78: © Walker Evans Archive, The Metropolitan Museum of Art
Plates 79, 82: © Hiromi Tsuchida
Plate 80: © Lauren Greenfield / INSTITUTE
Plate 81: Collection Center for Creative Photography, University of Arizona © 1998 The University of Arizona Foundation